FABRIC PAINTING

FOR

EMBROIDERY

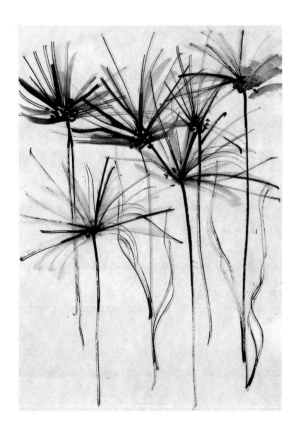

Valerie Campbell-Harding

B. T. Batsford Ltd, London

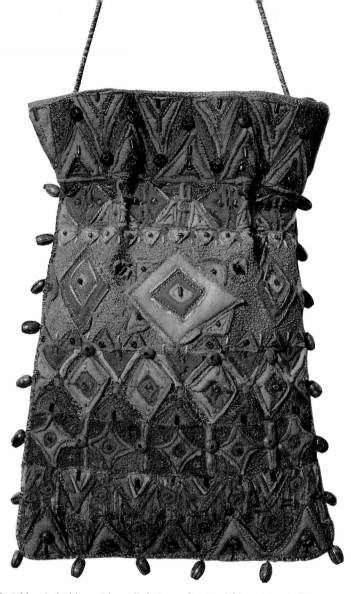

A richly stitched bag with applied pieces of painted felt and beads (Hilary Bower)

First published 1990
Reprinted 1992, 1994
First published in paperback 2001

ISBN 0 7134 8609 0

Typeset by Tradespools Limited, Frome, Somerset

and printed in Hong Kong

for the Publishers
B. T. Batsford Ltd
9 Blenheim Court
Brewery Road
London N7 9NY

A member of the Chrysalis Group plc

ACKNOWLEDGEMENTS

Very many special thanks to Linda Rakshit for her lovely
elegant drawings, without which this book would be the
poorer. Thanks also to Brian McNeill for taking and print-
ing the black and white photographs (apart from the ones
on pages 53, 126, 127, 130, 131, 134, 135, 138, 139 which
were taken by the author), making very early morning starts
to drive down to my house for photographic sessions.

My thanks to friends and colleagues for allowing me to
photograph their work, and also to my students at Urch-
font Manor College and Chippenham Technical College
in Wiltshire, summer school students at Great Missenden,
and also to Thea de Kock, Sandy Chester-Jones and
Angela Kay of the London College of Fashion.

I am grateful to Pfaff for the loan of a sewing machine to
stitch the samples; to George Weil for paints and fabrics;
to Vilene for bondaweb, stitch 'n' tear and vilene; and to
Whaleys of Bradford for some fabrics.

\mathcal{C}ONTENTS

\mathcal{I}NTRODUCTION

Embroidery is a term which now not only applies to stitchery on a fabric, but also covers methods such as quilting, appliqué, patchwork and fabric painting. In recent years many different fabric paints, crayons and felt pens have appeared on the market and been used by embroiderers to colour their fabric before embellishing it. There are many advantages to doing so, one main one being that there is no longer the need to keep a large stock of coloured fabrics. Another advantage is that there is more control over the result, and the finished work is more individual than when using commercially patterned fabrics. Working at home, or in a class or small workshop, allows flexibility as there are none of the constraints that there are in industry, and so the designs can be more creative.

These paint-decorated fabrics can be left as they are and used to make articles such as cushions and clothes; or the paint, depending on how it is applied, can suggest further embellishment such as quilting or a particular method of stitchery. The paints can be applied in a controlled manner to act as a base for a picture, perhaps a garden or landscape; or they can be used to give accidental, often unexpected, results. Fabric paints can be applied in many ways – by sponging, painting, printing, spraying or rolling – either directly on to the fabric, through a stencil or over a resist. However there are many different makes and there is often confusion over which to buy and how to use them. This book is intended to help restore order to the confusion.

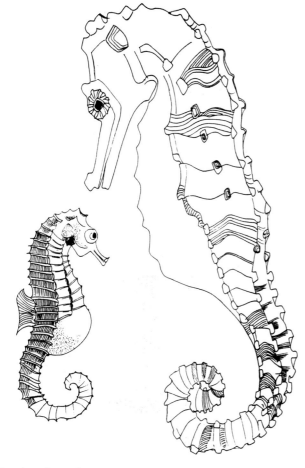

Drawing of a sea-horse

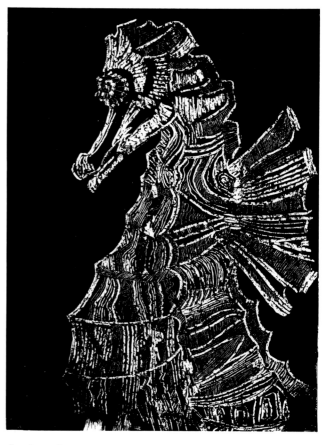

Sea-horse design scratched through black paint, which could be carried out using wax or gutta resist or painted on to a fabric (Joan Powell)

ABRICS

There is an enormous variety of fabrics available, at a wide range of prices. Expensive fabrics usually handle better, and look better when painted, but this is not always the case. Try the cheaper fabrics first, and if you cannot get the effect you want, then buy a more expensive version. If the embroidery is going to be backed, or quilted, then the handle of the fabric does not matter a great deal, and a cheaper one will certainly do.

The texture of the fabric is important, as a shiny satin, a transparent organza, or a slubbed, coarsely-woven fabric would each react differently to printing, for example. Also the colours look different on different fabrics, some colours becoming brighter or more subdued depending on the fibre or the finish. Try to collect a variety of fabrics, some with a shine, some with a loop or pile, some very smooth and closely woven, and some loose and open.

On the whole, it is better to choose white, cream or plain coloured fabrics for painting or printing on, although stripes or checks could be interesting as a base for many methods of applying paint. Commercial patterns are usually too dominant, although it would be interesting to try any small pieces you may already have to see what happens.

Certain fabrics are better suited to certain techniques: for example, while it is possible to sponge colour on to almost any fabric, it is necessary to use a man-made fabric with transfer paints or crayons. Once in a while, experiment with a seemingly unsuitable fabric just to see whether the results are justified. It would not seem sense to print a design on to a very open weave such as bandage or builders' scrim, yet it could give an interesting broken image.

PREPARING FABRICS

Many fabrics can be bought ready prepared for printing on (see suppliers' list p.143). This is a great convenience and time saver, and the fabrics retain their pristine newness. Any other fabrics, and all threads, need a good wash in the washing machine, or by hand in the case of silk threads or fabric, at the appropriate temperature. Unbleached calico needs much sterner treatment: soak it in cold water for a while, then wash it in the washing machine at the hottest setting; next boil it for half an hour with a quarter of a cup of washing soda (for a three yard length of fabric) and

enough water to cover it. Finally, rinse, dry and iron it. It is worth washing fabrics as you buy them so that they are all ready when the urge comes to colour them. Keep this supply separate from your general fabric store.

MAKING TEXTURED FABRICS

Although printing and painting are mostly done on fabrics as they are when bought, it is often more interesting to make up a textured surface to work on, and there are various ways of doing this using fabrics which have been cut or torn, or with burnt or frayed edges.

1. Strips of fabric can be woven together. Use either a single fabric, or a mixture of different ones, and secure the weave either by stitching around the edge, or by backing with iron-on vilene.
2. Strips of fabric can be bonded or stitched on to a background fabric. They can be spaced out or overlapped, and need not all be in the same direction.
3. Small pieces, squares or cut shapes of fabric can be bonded to a backing fabric to build up texture or pattern.
4. Fabrics can be slit or have holes cut or burnt into them before use.
5. Fabrics can be gathered or ruched.
6. Fabrics can be tucked or pleated, and the tucks or pleats held by ironing or stitching.

Although it is possible to sponge or roll colour on to a very textured base, when it comes to printing, try a sample first to see whether the base is flat enough to accept the print.

A background fabric made by bonding strips of silks and transparent fabrics with burnt edges to a calico ground. This can be sponged, rolled or overprinted

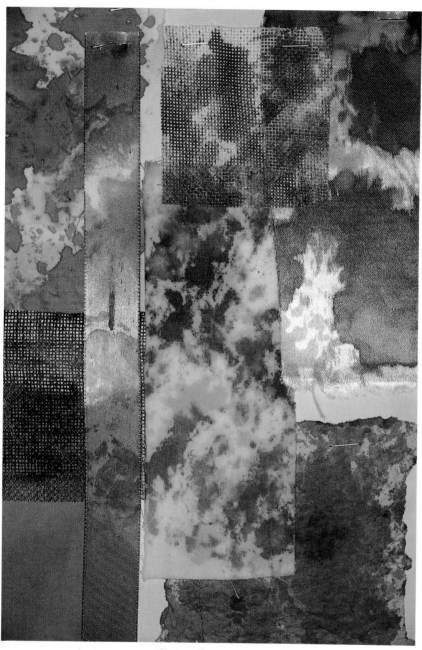

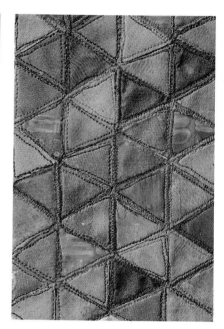

A detail of an appliqué piece. Small triangles of sponged and waxed fabrics were bonded to calico. Straight and satin stitch were machined around the triangles to give extra colour and definition.

The same paint sponged on to different fabrics.

RIGHT *Detail of a panel using sponged fabrics. The background is smooth, with squares of applied gathered fabrics applied on to it. Free running and whip stitch were machined in a grid pattern between the raised pieces (Angela Kay)*

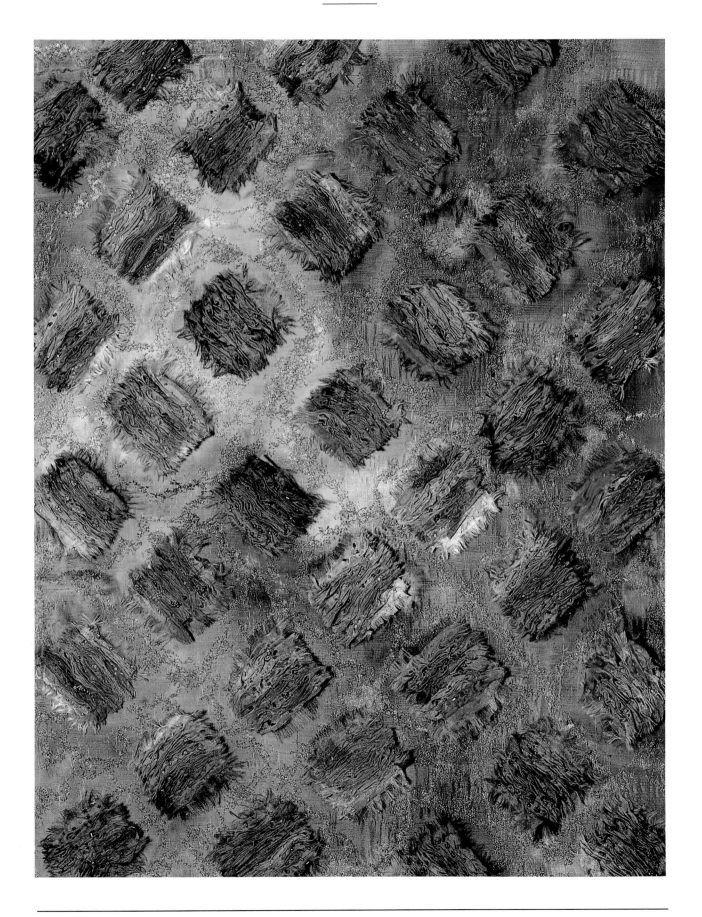

ATERIALS AND EQUIPMENT

A certain amount of the equipment needed for colouring fabric is specialized, but it is possible to use many things you may already own and try out some methods before deciding to spend money on more expensive items.

FRAMES

The fabric should be usually kept taut while applying the colour; the best way to do this is to mount it on a wooden frame or an old picture frame. It does not need to be quite as taut as for embroidery. Another way or securing the fabric is to tape it around the edges to a piece of formica board, or on to a polythene bag which has been taped to the top of the table or a drawing board. For quick experiments, you can just lie small pieces of the fabric on a bed of newspapers, but this will not give good results with larger pieces.

BRUSHES

You will need some pointed brushes for painting between lines of resist or straight on to fabric, but I use flat, wedge-shaped brushes more than anything else: for applying paint or bleach to the fabric, for applying paint to a printing block, and for mixing colours. Fan-shaped brushes, sold as blender brushes, print fan shapes beautifully. Stencil brushes are harder, for stippling and dabbing paint through stencils. Household paintbrushes, bought in cheap lots, are useful for covering large of fabric with

colour. Save your old toothbrushes, as they are surprisingly useful for dabbing, streaking and splattering paint on to fabrics.

Look after your brushes, as they are expensive. Wash them carefully and stand them bristles up to dry. Do not allow bleach or any other corrosive substance to remain on them for a long time. Once brushes have been used for waxing, they are unfit for anything else.

OTHER EQUIPMENT

Many things you already have will be useful, such as cotton buds, old mapping pens, old plates and saucers for mixing paint on, masking tape, erasers to cut into for printing, old sponges, and pins and scissors.

A worktable for many of the processes needs to be quite sturdy so that you can press down on it. Cover it with a thick layer of newspapers to give a resilient surface for printing on, and make sure that the floor underneath is washable. In the summer you can often work outside it it is not too windy, and any paint spilt will get mown away the next week.

It is best to avoid buying specialized equipment such as wax melting pots until you are sure that you wish to do a great deal of waxing. Sometimes, if you know how a process is done, you can fudge an alternative, cheaper method. However, the real equipment is always more efficient and a joy to use.

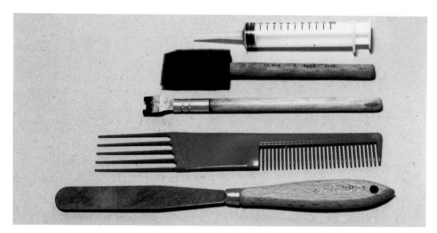

Some of the tools available to apply paint with – a gutta bottle, sponge brush, calligraphy pen, comb, palette knife

A piece of silk stretched on a frame with the design drawn on it in pencil, ready for applying gutta or wax

SAFETY

It is right to be aware of the possible hazards connected with the use of paints, dyes, bleach and other substances that we use when colouring cloth. Safety is relative: all non-food substances are potentially harmful, even though the body is very adept at ridding itself of minor irritants. Most substances are toxic when used in large quantities (equivalent to drinking a large cup of paint). Common sense and normal precautions should, however, be enough, combined with the fact that we are not likely to be using very large quantities of toxic substances, nor using them all day and every day.

- Wear rubber gloves when working, as prolonged or repeated contact between the skin and any substance should be avoided
- No chemical should be eaten, drunk or sniffed
- No food, drink or smoking should be allowed near the worktable
- No utensils or equipment used for painting should also be used for domestic purposes. Keep old or disposable spoons and pots with the paints.
- Avoid inhaling powders, bleach or sprays by handling them carefully and working in a well ventilated place. If you are doing a lot of work, wear a mask, which can be bought from a chemist.
- Leave all jars and bottles in a safe place where children and animals cannot get at them

THE DIFFERENCE BETWEEN DYE AND FABRIC PAINT

Many people call fabric paints dyes, which they are not. A dye is a water-soluble substance which penetrates the fibres and colours them. The dye molecules bond with the fibres in different ways, depending on the type of dye used. Dyes are completely transparent, which means that the colour of previous dyeing can be altered. Dyes do not change the handle or feel of the fabric.

Fabric paints are made from pigments which are not water-soluble and are held on the surface of the fibre. They are ground extremely finely and dispersed into emulsions or pastes. Some paints make the fabric a little stiff, but this often disappears after washing. They are not transparent, although when used very thinly they can seem so.

TESTING FOR FASTNESS

Always test all paints and methods for light and wash fastness when doing a final piece. This is not necessary for samples and trials, but is especially important if a piece is to be sold or is envisaged as an heirloom.

For light fastness, cut the piece of fabric in half. Keep one half in a drawer and tape the other to a sunny window for a few weeks, then compare them. Everything will fade a little, but the difference should not be too obvious.

For wash and cleaning testing, repeat the washing/or cleaning processes a few times, depending on the purpose of the finished article.

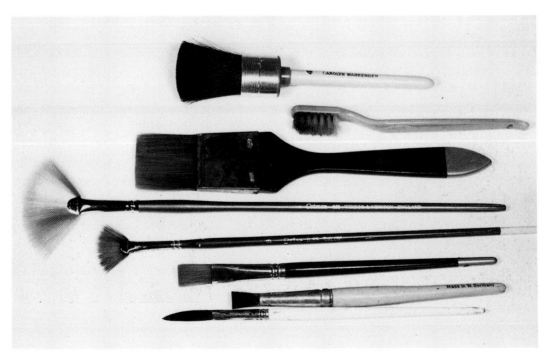

Different brushes available – watercolour, one-stroke, fan, household, toothbrush and stencil brush

FABRIC PAINTS

There are so many different brands of fabric paints available that it can be confusing and often difficult to make a choice. However, this is not as hard as it may seem at first, as they fall into two main groups. The largest group contains general purpose paints and crayons which are suitable for any fabric and are applied to them directly. The smaller group are transfer paints and crayons which are suitable for man-made fabrics; these are applied to paper and then ironed on to the fabric.

GENERAL PURPOSE PAINTS, PENS AND CRAYONS

These paints are pigment emulsions and can be thinned with water. Opaque colours are useful for applying to dark fabrics or to block out other colours, and transparent colours are useful for overlapping and revealing the sheen of the fabric. These media are obtainable in a wide range of colours, including metallics, pearls (both of these are always opaque), and fluorescents. The colours are mixable within the same range, but not always between ranges, as they can curdle; they can also be mixed with an extender medium to give tints. The paints are fixed by heat, either by ironing on the wrong side of the fabric, using the hottest suitable setting, for 4–5 minutes in the same area, or by using a hairdryer, or in a tumbler dryer, or by baking in an oven for 4–5 minutes at 140°C (284°F). Once fixed, they are machine-washable and dry-cleanable. Some paints are thick and are most suitable for printing with, while some are thin and more suitable for applying within outlines of

wax or gutta, to keep them from spreading, or for purposely flooded and blended effects. Others are thinner still, like ink, and are sold for use in air-brushes or packaged as felt pens. A few brands are packaged for schools and colleges as a concentrated colour paste which must be mixed with a medium before use. Although cheaper, these do not last long when mixed. Fabric crayons are wax crayons which are heat set like the paints, and only come in a small range of colours.

It is best to wash the fabric gently after the paint has been set to remove the flat look and to soften it.

SILK PAINTS

Some thin silk paints are fixed by chemicals or steaming. These are more bother, but give more glowing colours. Many of the methods of applying paints can be used with them, but follow the manufacturer's instructions for fixing them, which can be done easily at home in a pressure cooker. A thickener can be added to silk (or any other thin) paints so that they can be used to print with. Match the brand of thickener to that of the paints.

TRANSFER PAINTS AND CRAYONS

These are sometimes known as iron-on paints, and are made from a disperse dye in the form of a paint or crayon. They are applied to paper and allowed to dry. The paper is then placed upside-down on a piece of fabric and ironed to transfer the colour. No further fixing is necessary. They are most successful on fabric that is at least 60 per cent synthetic, and are not fast on fabrics made from natural fibres, unless 'Cotton Finish' is used on cotton first (see page 86). They are machine-washable and dry-cleanable. One disadvantage is that the colour is not the same on the paper as it becomes when ironed on to the fabric, although some brands match better than others. Tests should be done to see what the changes are on the fabric that is to be used.

LIGHT SENSITIVE PAINTS

Pebeo Setacolour transparent paints react to the sun. Use them diluted with up to two parts water. Moisten the fabric, apply the paint by any appropriate method, lay a mask on top and allow the fabric to dry in the sun. As a

General purpose fabric paints and crayons

mask, feathers, leaves, meshes, grids, lace or cut or torn paper shapes can be used. The uncovered fabric becomes darker: ironing prevents any further change.

OIL INKS
More difficult to find are oil-based printing inks, often sold for marbling. They are diluted with white spirit and need no further fixing after they are dry.

SPRAY PAINT
Car spray paint is often used on fabric and is very convenient, although may not be fast for ever. A spray paint for fabrics, used by flower arrangers for colouring ribbons, is better. Either can be used on any fabric.

ACRYLIC PAINT
This can be used on fabric when thinned down well to avoid stiffness. It does not need fixing and can be used on any fabric. The metallic colours are especially useful.

PROCION MX DYE
Procion dyes are suitable for cotton, rayon, silk or linen. They can be thickened with Manutex to make a printing paste, and can be discharged with bleach to give different colours. The fabric is first treated by dipping in one litre of water combined with 10g (3½oz) of soda ash or 20g (7oz) of washing soda. Dry and iron the material. Dissolve half a teaspoonful (or less) of Procion in 50ml (1¾fl oz) of cold water. This can be used as it is, or thickened by mixing it with 12g (2 heaped teaspoonsful) Manutex mixed with 100ml (3½fl oz) tepid water, and well stirred. Prepare the thickener several hours before needed. More dye, water or thickener can be added to alter the colour of the consistency, and the mixture used in the same way as a general purpose fabric paint. Procion will only last for four hours after mixing. Allow the paint to dry thoroughly. Then fix the colour by baking or ironing in the same way as general purpose fabric paints. Rinse excess dye off first in cold water, then boil the fabric for about five minutes in water with a little detergent added. Rinse again in cold water and dry.

HEAT EXPANDING PAINTS
These come in tubes or bottles and look puffy when ironed, or like flock when screen-printed. They can be diluted with water, applied with a brush, and used with stencils or as narrow lines drawn with the tube. They are heat set by ironing without too much pressure on the back of the fabric at the silk/wool setting.

AQUARELLA
This is a Victorian substance designed to be mixed with watercolour (preferably in tubes) to make it a fabric paint. It can be painted over coloured pencils and wax crayons already applied to the fabric to make it fast to washing.

COLOUR AND TONE
The generally accepted colour theory for anyone using pigments is based on a colour wheel that includes the three primaries – red, yellow and blue – that cannot be obtained by mixing. It also includes the secondaries – green, orange and violet – that are obtained by mixing any two primaries together (see p. 16). However it is usually impossible to obtain pure primaries in pigments and therefore becomes impossible to mix the secondary colours. The green tends to be muddy, the violet is quite brown, and the orange is not bright enough. It is a better idea to use a colour wheel that gives two reds (a slightly orangey-red and a slightly bluey-red), two yellows (a slightly greeny-yellow and a golden yellow), and two blues (a slightly violet-blue and a slightly greeny-blue) (see p. 16). It is then easy to mix orange (the yellowy-red and the golden-yellow), violet (the bluey-red and the violet-blue) and the green (the greeny-yellow and the orangey-red). This second colour wheel makes sense because you can then buy two yellow, two red and two blue dyes, inks, paints or crayons, knowing that you can obtain from them any colour that you wish. If you add black and white to this list, then you can also mix any tint or shade that you need. You will not have a mass of tubes and bottles to store, you will have saved money, and the mixing will give you the results you want.

Hue This means the brightest pure colour anywhere in the colour circle

Silk and transfer paints and crayons, and fabric felt pens

Tint This is the term for a hue plus white

Shade This is the term for a hue plus black

Tone This is the term that describes the lightness or darkness of a colour and includes all the tints and all the shades of a single colour

Tertiaries The term for the colour mixed from a primary and the secondary next to it (red/orange, yellow/orange, yellow/green, blue/green, blue violet, and red/violet)

Analogous colours are those which are near each other in the colour wheel (red, red/violet, violet, and blue/violet, for example). These colours look rich and vivid together

Complementary colours The advantage of the first wheel is that with the three primaries and three secondaries it shows you instantly which colours are complementaries: that is, opposite each other on the wheel. Thus red is the complementary of green, blue of orange and yellow of purple. Tertiaries also have complementaries: red/orange is complementary to blue/green. Tints and shades are also included – pink is complementary to pale green. Complementary colour schemes are always successful, and the mixes of any two sets of complementaries give us those wonderful subtle colours that we need to set off the primaries and secondaries. A small amount of a complementary colour will liven up a colour scheme. When large areas of complementary colours are next to each other, they make each other more vivid – red makes green look greener and vice versa.

Spectrum The spectrum includes all three primaries and all three secondaries. It includes only those six colours (not a seventh, which was a figment of Isaac Newton's imagination. He thought that everything should go in sevens and therefore added indigo to the list of spectrum colours.)

Warm and cold colours The warmest colour is orange, but yellows, reds, and some pinks are also warm. The coldest colour is blue, but turquoise, greens and violet are also cold. Colours are made warmer by adding red or yellow, and cooler by adding blue. It is possible to have a cold blue (greeny-blue) and a warm blue (a violet-blue), and this applies to all the colours. On the whole, warm colours come forward and are useful in the most important areas of a design, while the cold colours recede and are better in the background.

Achromatic means without colour: black, greys and white

Monochromatic means all one colour, but this can include all the tones of that colour

Colour schemes Ideas for colour schemes can come from colour theory – such as using an analogous or complementary colour scheme – or they can come from closely observing a colour scheme in nature or a photograph. Look very carefully at an object in good daylight, and record the colours either in paint or coloured pencils, or by choosing threads from your collection. Be careful to get every little fleck and variation of colour and tone, because this is what makes the colour scheme interesting. Most people, if working from imagination, will choose two or three colours, but nature will include many more. Also record the tints and shades of the colours, and the correct proportion of each one.

Tone It is very important to consider tonal contrast in a design or a colour scheme. Dark tones (shades) give an impression of strength and richness, and light tones (tints) give an impression of delicacy. Many colours of equal tone put together can make a wonderful colour scheme, but more often some tonal contrast is needed, using dark and light tones to emphasize different parts of the design. The proportion of dark to light tones is also important, as they should not be equal amounts. If there are many light and mid-tones, then a few small areas or lines of something very dark will attract attention straight away. The reverse is the same – if there are many dark tones, then the very light areas will attract attention.

Often colour schemes fail because they do not include enough different tones. The combination of red and green is, perhaps, ordinary; but if many different tones of red are included and a few tones of green, the whole thing will become more interesting.

If a design is planned using dark, medium and light tones, substituting colours in their place will not alter the design if the tones are kept the same. Dark red could be used instead of black, sepia instead of grey, and cream instead of white. However, if the tones are placed in different areas in a design, the look of it will change totally. A simple tonal change will make a more interesting design out of an all-over pattern. All the dark areas could be around the outer edge, giving a darker border around lighter field; or the dark areas could be grouped down each side; or start at one corner and move diagonally across to the opposite corner.

Woven newspaper design This design method concentrates on tonal values. If the design works in black, greys and white, then colours can be substituted afterwards.

1. Cut strips from newspaper pages in a variety of widths from 2cm (3/$_4$in) to 94cm (1^1/$_2$in). Include some large type, some small print, and parts of pictures in a range of tones. Weave the strips together and secure on the back with tape.

2. Cut a hole about 5cm (2in) square in a piece of paper. Place it over the weaving, moving it about and altering the

angle, until you find an area that you like which includes curves and straight lines.

3. Place a piece of tracing paper under the window, over the weaving. Draw around the edge of the window, and then trace around any shapes you wish (including blocks of small print, large letters, and parts of pictures).

4. Photocopy the tracing three or four times.

5. On one photocopy, fill in some areas with black felt pen, and some with pencil or fine black lines, to give grey areas. Leave some white.

6. On a second photocopy, fill in different areas with black and grey. Photocopy your design a number of times and see what happens when you cut different versions out and place them touching each other to make a larger pattern. What shapes do the black areas make? Do the same thing with your second design and see the difference. Try different arrangements such as half-drop patterns and mirror-image patterns, still looking at what happens to the black shapes. Sometimes they will help the design, and sometimes they will detract from it.

ABOVE *A woven newspaper design*
RIGHT *Two different patterns traced from the design; one was chosen and areas filled in with black and grey to show how change of tone can affect a design*

A block used to print tone variations

The usual colour wheel containing three primaries and three secondaries

The double primaries colour wheel, showing two yellows, two reds and two blues

A design showing hues against a background of tints

ABOVE *Wrapped threads on strips of card showing a subtle colour scheme using a tint of violet (lilac) and a shade of yellow (olive green), plus gold. This colour scheme, reversing the usual tones of the colours, is called a discord (Mollie Edwards)*
RIGHT *Red, blue & yellow (gold) plus black make a subtle colour scheme. The design for this collar was based on patterns from Ancient Egyptian mummies. Painted fabrics & pelmet vilene with machine stitching (Marian Murphy)*

\mathcal{U}SING SPONGES

Many kinds of sponge are easily available and can be used to colour fabric in different ways. The texture of sponges can be exploited fruitfully, natural varieties having large holes which, when used with fairly dry paint, make interesting marks on fabric. Alternatively, make-up sponges, which are man-made and very smooth, can be used to print shapes. Sponges can be carved or cut into simple shapes. Flat household sponges can be cut into shapes such as hearts or leaves, or the edges of small pieces used to print with. Commercial printing blocks are available (see suppliers' list, p. 143) with cut shapes of extremely fine quality sponge glued to a plastic block for ease of handling.

BLENDED COLOURS
Tape the fabric to a smooth board covered with plastic or cling-film. Dip a wet sponge into an old saucer filled with silk paints, Procion dyes or diluted general purpose paints, and press it on the fabric. The colour should flood over fine fabrics, but if not, then dip the sponge into water and press it all over the fabric. Alternatively, the fabric can be dampened beforehand. Different colours can be sponged on the fabric at the same time so that they blend into each other, or the first colour can be allowed to dry before adding another. Where the colours overlap they will mix.

These fabrics can be used as they are, or as a base for further decoration as the flooded colour effects make a good background for printing, rolling or screen printing.

Sponging can be done on plain fabric, on fabric that has already been tucked or pleated or manipulated in some way, or on finished embroidery. As different fabrics take the paint differently, it may be worth doing some appliqué, or strip patchwork, using a variety of fabrics, and then sponging the whole thing afterwards.

SALT EFFECTS
Salt can be used with silk paints and Pebeo Setacolour Transparent fabric paint to give an effect obtainable in no other way. Although this does not work with most general purpose paints, it is worth trying with anything new just to see what happens.

As soon as the paint has been applied to the fabric, sprinkle coarse salt on it. The salt causes the colour to migrate, leaving textured areas. When the fabric is dry, shake the salt off into a jar, as it can be reused. Special salt for this purpose is distributed by the silk paint manufacturers, but coarse kitchen salt is just as good.

TEXTURE EFFECTS
Dry sponges with very little paint on them produce a textured effect, while wet ones give a softer result. Sponges can be dabbed freely or streaked on to the fabric, using varying pressure. Paint can be pressed through a mesh or net to give an all-over pattern, but be careful to use a very small amount of paint when doing this, as it is inclined to run under the mesh and ruin the pattern. It is also better to use a thicker fabric such as calico, or to put blotting paper under fine silk to stop the paint running.

Fabric paint being sponged on to a dry fabric

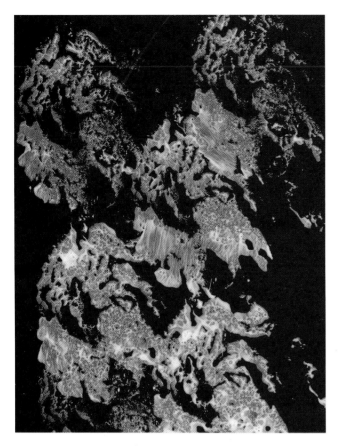

Paint sponged onto a dry fabric

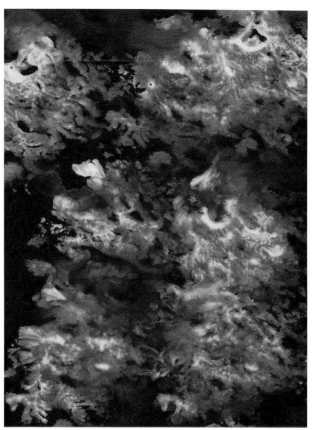

Paint sponged onto a wet fabric

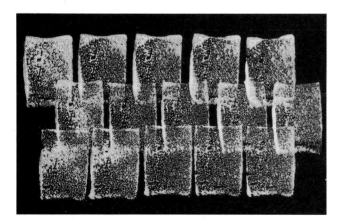

Patterns made using a rectangular piece of sponge

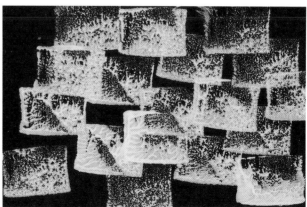

A drawing on sponged paper

A design using sponged papers built up in layers

Machine cutwork using the design (Sue Luttmer)

Paint sponged through a mesh fabric on to small pieces of lurex fabric and silks bonded onto calico

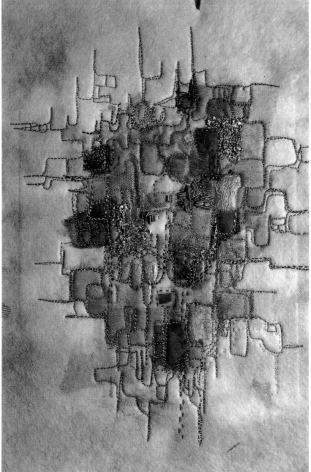

Sponged fabrics applied to felt, also sponged. Free running was added to define the pattern and cut gold purl emphasised certain areas (Yvonne Morton)

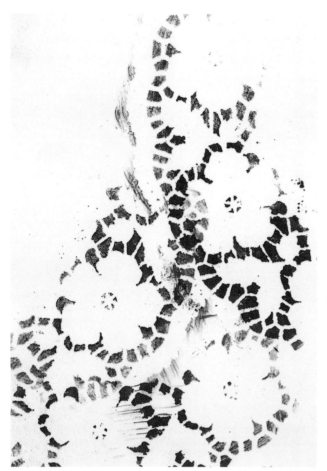

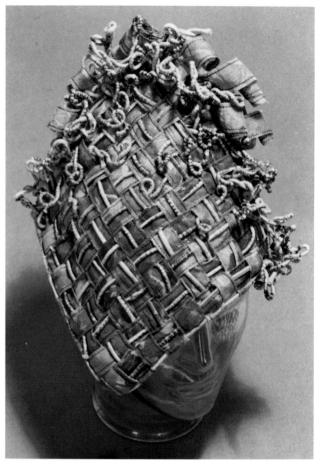

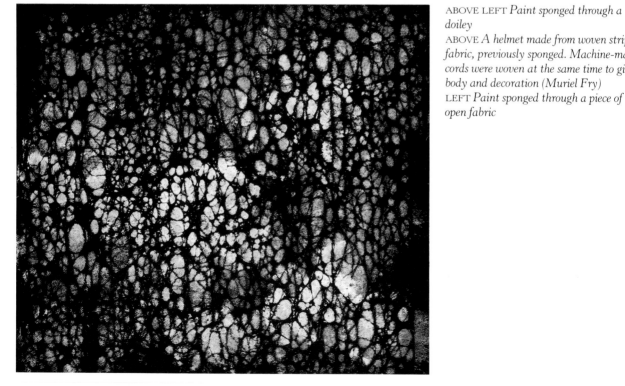

ABOVE LEFT *Paint sponged through a doiley*

ABOVE *A helmet made from woven strips of fabric, previously sponged. Machine-made cords were woven at the same time to give body and decoration (Muriel Fry)*

LEFT *Paint sponged through a piece of open fabric*

PRINTING WITH SPONGE BLOCKS

Man-made sponges can be cut or carved to give a shaped block which can be printed. Draw a pattern on the sponge with a felt-tip pen and use scissors or a craft knife to cut away the background areas. Sponges are rather soft to print with, and do not leave much detail in the cut shape, so it is best to keep them for large-scale work.

Commercially made sponge blocks (see suppliers' list, p. 143) are made from a very finely textured sponge and are more intricately shaped. These are not originally designed to be used with fabric paints but are nonetheless extremely successful. Roll general purpose fabric paint thinly on to a glass plate; dip the sponge block into it and then on to the fabric. Fabric paints dry out quite quickly on glass, so only use a little at a time. If a large amount of printing is to be done, saturate a piece of felt in a saucer with the paint and dip the sponge into that instead.

CRYSTAL PATTERNS

This method gives angular shapes reminiscent of crystals, with shiny and matt areas on the fabric. Lay a piece of cling-film on the table, place a fine silk fabric on it and sponge with silk paints so that it is fairly wet. Using a brush, push the fabric towards the centre so that some areas are left touching the cling-film and some rise in folds above it. Leave to dry, then pull away from the plastic.

LEFT *Sponge blocks, home-carved and commercially made*
BELOW *Some patterns printed with sponge blocks, overprinted with rubber stamps to suggest stitchery*

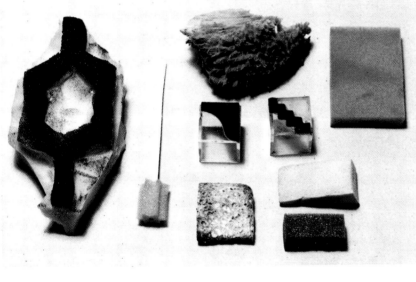

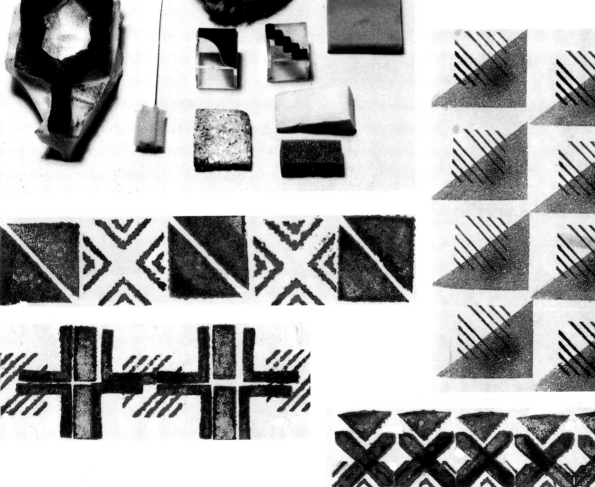

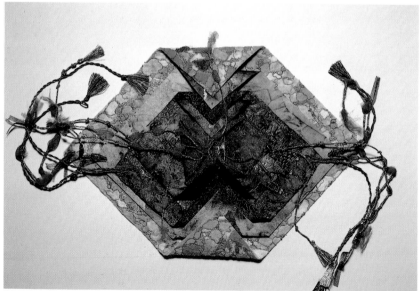

ABOVE *The sponged fabric used on page 22 (bottom left)*

LEFT *A 'book' made using sponged felt, silks, and vilene, with machine embroidery adding colour, giving body to the fabrics and defining the pattern. The cords are made of strips of transparent fabrics zigzagged by machine (Mollie Edwards)*

RIGHT *A panel built up using various pieces of sponged and painted fabric and machine embroidery. The design is based on the letter G, and the techniques include cutwork, couching, drawn thread, free running, stitching and slashing, stitching on soluble fabrics and herringbone worked by hand (Marian Murphy)*

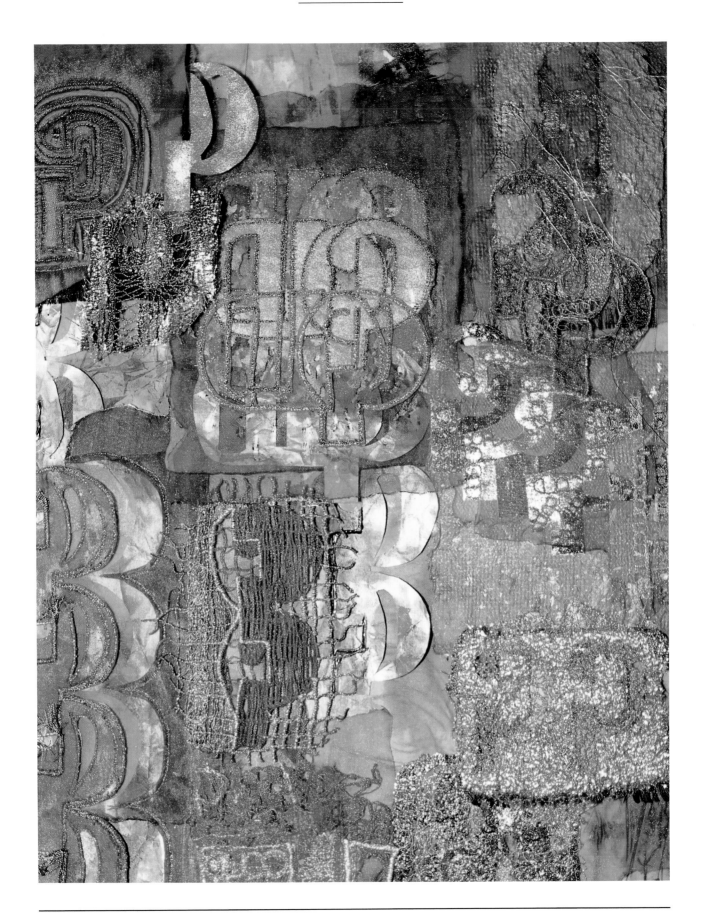

\mathcal{U} SING STICKY PAPER AS A RESIST

Various sticky-backed film, tape, and ready-cut shapes can be used on fabric to resist paint. Low-tack film can be cut into shapes, the backing paper peeled off, and the shape stuck to the fabric. Masking tape comes in different widths, and can be used to make striped patterns, but can also be used cut into short lengths to build up patterns such as crosses. Stars, ring reinforcements and labels can all be used in the same way. Holes or strips can be punched in or cut from lengths of tape before use.

Tape the fabric to a board (covered with plastic if you wish to protect it). Stick the tape or shapes to the fabric, pressing firmly. Sponge general purpose or silk paints on the fabric and leave to dry. The thicker paints can be brushed, rolled or dabbed on instead to give different marks or patterns. Peel the paper off when the paint is dry.

Masking tape does not always give a complete resist, depending on the fabric used and how thin the paint is, and the effect of the paint seeping under the edge gives a softer line.

Quite complex patterns can be built up by repeating the process, with the strips or shapes being placed in different areas each time, and different colours used. The first layer of paint can be sponged on, and the second layer applied by a different method, using a different colour or stronger tone. Further patterns can be block or screen printed on top, or drawn with fabric pens.

ABOVE *Brushing fabric paint between lines of masking tape on fabric*
RIGHT *Fabric decorated by sticking white labels onto it and brushing fabric paint over them. When the paint was dry, the labels were pulled off.*

Patterns made by sticking strips of masking tape, cut pieces of masking tape, ring reinforcements and pieces of masking tape with holes cut in them, on to fabric and painting over them

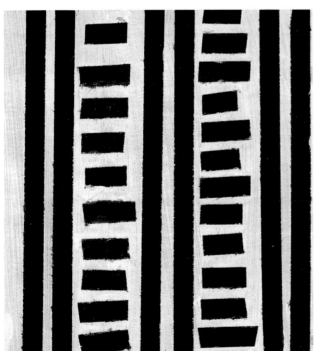

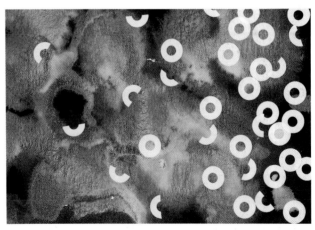

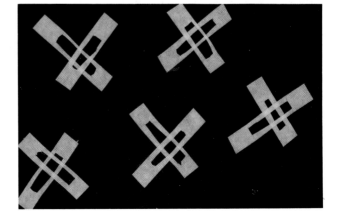

Fabrics showing the effects made by using silk paints which are not completely resisted by the masking tape and therefore give soft edges.

ABOVE *Pattern made by sticking sticky-backed hearts and masking tape on to fine silk and painting over the shapes with silk paint*

LEFT *Patterns made by using long lengths of masking tape, making diagonal stripes*

Two fabrics showing the effect made by using thicker, general purpose paints and masking tape, which gives a clean resist
ABOVE LEFT *Extra strips of transparent fabrics have been stitched over the painted fabric, and lines of glitter paint drawn on*
ABOVE *Drawing showing a bubble jacket which could be made of tape-resist fabric*
LEFT *The original fabric, first painted gold over torn paper shapes, then covered with strips of masking tape and painted white. It was then cut into strips and woven with black velvet ribbons and strips of fabric decorated with narrow gold ribbons stitched using an automatic pattern*

PAINTING ON THREADS

Often, commercially dyed threads are too hard-looking, or not the right tone or colour to use on a fabric you have coloured yourself, so you may want to colour your own threads at the same time. There are various ways of doing this suitable for the small quantities needed for embroidery and which will produce threads sympathetic to the coloured fabric.

Too much paint will stiffen the threads, but washing after setting the paint will often soften them again. If possible, use the thinner silk paints, even the intensely coloured ones, or Procion dyes if you want strong colours. Experiment with glitter or metallic paints, although these threads might not pull through a closely woven fabric very well and might have to be couched, used on a loosely woven fabric such as scrim, or used as the top layer of a composite stitch.

Different fibres will take the colour differently and it is worth trying cotton, rayon, linen and silk threads at the same time to see the different results. Also combine smooth and textured fabrics in the same batch, as well as ribbons, tape or strips of fabric or nylon tights.

SPONGING

Lay a skein of threads in a flat dish or on a sheet of polythene, and sponge fabric paint over it. Do not try for an even result, but aim for shading in a single colour, or mixed colours giving a random effect. Do not use so much paint that you leave pools of colour under the threads; use a little, let it dry, and repeat the process for a stronger colour or to fill in bits you have missed. Turn the skein over to see if the back is coloured. Dry and fix the colour.

PAINTING

1. Using a brush, paint the colour on a reel of thread, either all over or in stripes. You will need to re-paint the reel as it is used up.

2. Wind the thread around a piece of card or polystyrene, an old picture frame, square embroidery frame, or plastic bottle, and paint it with a brush. The threads can be painted in stripes, blobs, or streaks.

3. Wind the threads around a piece of card or old frame, then, using embroidery paste in a tube or coloured paint in a gutta bottle, paint spaced lines of colour on to the threads on both sides. This gives a spotted effect. Dry and fix as before.

RESIST METHODS

1. Tightly wrap a skein or hank of thread at intervals using an impervious material such as raffia. Sponge paint on unwrapped areas, or dip them into dilute paint. Dry and fix. Unwrap the raffia. Areas of colour can be re-wrapped and the process repeated in a different colour.

2. A skein of thread can be plaited, the colour sponged on, and then unplaited after drying.

PRINTING

Printing on loose skeins of yarn, or yarn wrapped over a piece of card, gives a speckled effect. You can print with a flat or fan-shaped brush, or with a block of some sort. Do not aim for a recognizable print, but rather to make the thread compatible with a fabric printed with the same block.

Painting a skein of thread, knotted to resist the paint

\mathcal{T}HREAD WRAPPING AS A RESIST

An advantage of this resist method of colouring fabric is that the fabric and thread are coloured at the same time, and could be used together later.

Wrap a piece of fabric around a large plastic drainpipe, or a large cardboard roll protected with cling-film. Do not use too many layers of fabric or the paint will not penetrate them. (Obviously it is possible to use more layers of muslin or very fine silk than of cotton.)

Tape the end of a thread to one end of the tube, and tightly wrap it round, spiralling up to the other end. Cut the thread and tape the end to hold it in place. The wrapping can be even or not, as you prefer. A second thread can be wrapped in the reverse direction to give a different pattern. The wrapping should be extremely tight to resist the paint. The thread used can be smooth or textured, thin or thick. If the thread is only to be used to make a resist pattern, then a plastic thread is best.

Using thin silk paints, diluted general-purpose paints or Procion dyes, paint or sponge them on to the tube. Procion is more penetrating than the paints, but, even so, the inner layers will usually be paler than the outer ones. Allow to dry, or dry with a hair-dryer. Remove the thread

and unroll the fabric. Fix the paint as usual. The indentations in the fabric made by the thread can be left or ironed away.

Painting a fabric-wrapped tube, with thread wrapped around it to resist the paint

Patterns made by using different threads

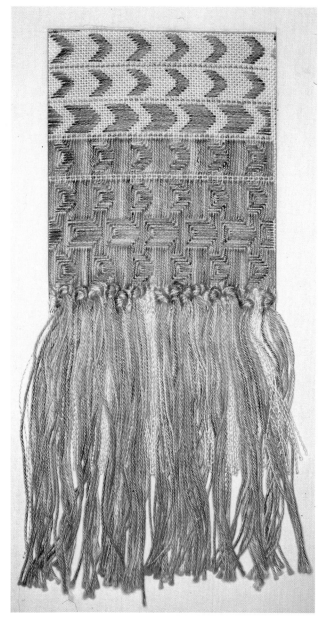

Stitch samples using painted threads: LEFT *damask darning,* BELOW *needleweaving*

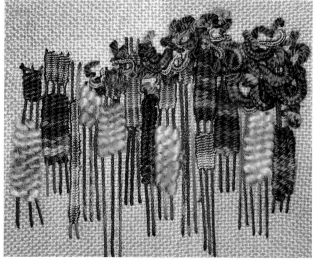

Fabric wrapped with two different threads

GATHERED AND STITCHED

RESISTS

Gathered and stitched resists have a long history. In Japan the technique is called *Shibori*, in the East Indies, *Tritik*. In Nigeria and the Cameroon, raffia sewn on cotton acts as a resist to indigo dyeing. The principle is that stitching on a fabric resists the dye or paint, leaving a mark where the stitch was, or that the stitching is used to pull fabric into folds that resist the dye or paint. Other methods of securing the gathers are now being used, for example as tube-tying.

With any of these methods it is more interesting if two, three or four colours are applied, allowing them to merge into one another, rather than only one.

TUBE TYING

Loosely roll a piece of fine silk or muslin about 45cm (18in) square on a piece of plastic plumbing pipe about 50cm (20in) long. Tie one end firmly round the tube. Force the fabric towards the tied end as far as you can (twisting as you go gives a different pattern). Tie the other end firmly to avoid any slipping.

Apply silk paint, dilute fabric paint or Procion dye with a sponge or a brush. Dry naturally or with a hair-dryer. Undo the ties and open the fabric out to finish drying. Iron to fix if using paints.

On some fabrics the colours will become paler and the pattern less intense on the inner surfaces, giving an interesting change. However, if you do not wish this to happen, use a much bigger pipe and only wrap one layer of fabric around it.

The fabric could be pleated before being tied on, the pleats being held in place by ironing, then push to gather as before.

GATHERED RESIST

Fabrics can be gathered by hand, on a sewing machine or on a smock-gathering machine. Using a strong or doubled thread, work all the stitching then pull the threads very tight before fastening them off. Dab silk paint or Procion dye on the folds of the fabric. Dry it and undo the threads. Iron the paint to fix it. The fabric can be gathered again in

either the same or the opposite direction, and painted again. The folds, and therefore the colour, will not be in exactly the same place as before. A third layer of colour can be added, which could be metallic paint just touching the top edges of the folds. Dry and fix.

The fabric can be pleated before the gathering, which gives a strong pattern of lines and bands crossing the folds at right angles. Try gathering in the same direction as the pleats, and through them, and also try gathering across them at right angles.

STITCHED RESIST

A fold in the fabric can be oversewn closely and tightly using a strong thread, or raffia. This can be left flat on the surface, or pulled up so that the fabric bunches up on the thread and covers it.

Running stitch can outline a shape such as a circle or a leaf. Stitch around all the shapes in the pattern leaving the ends hanging. When the stitching is finished, pull each thread in turn as tightly as possible and finish off. Paint the fabric puffs, leaving the background plain. Or each shape can be covered with a small piece of polythene to protect it, bound to hold the polythene in place, and the background

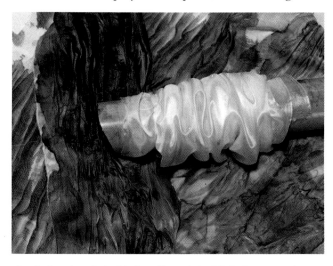

A tube loosely rolled with fine silk, and the fabric from a previous batch

areas painted. Alternatively, just sponge paint over the whole piece of fabric, and the stitches will resist the paint, leaving the shapes outlined but in the same colour.

Embroidery can be worked on a fabric using a synthetic thread that will resist the paint better. Thick threads or raffia will leave a stronger pattern than fine ones. Hand and machine embroidery produce different effects and further stitching can be worked between layers of different coloured paints. Start by dabbing or sponging the palest colours and build up to the darker ones. Remember that each layer of colour will be altered by the next one (blue turning yellow to green, for example).

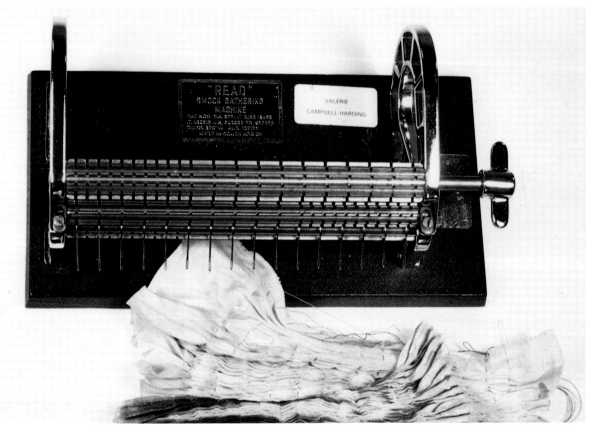

A fabric gathering machine

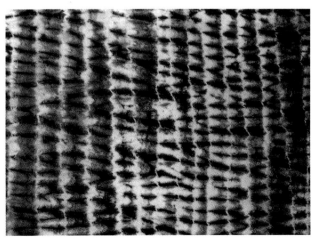

A machine gathered fabric, sprayed before removing the gathering threads

A hand gathered fabric, painted

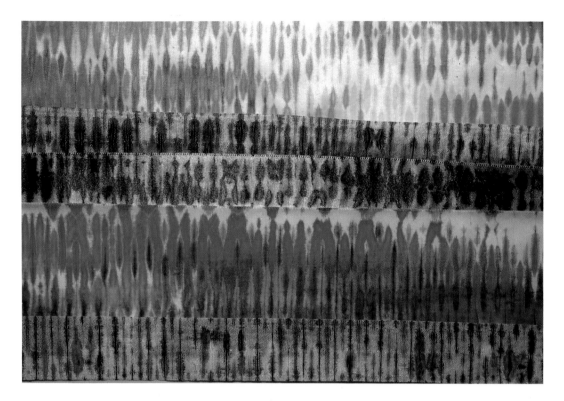

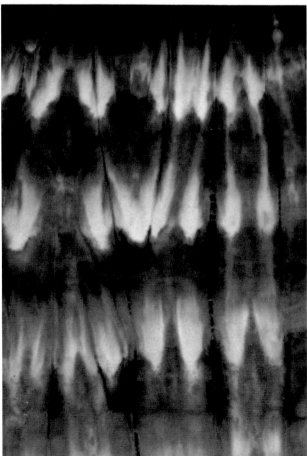

ABOVE *Gathered, painted ribbons*
LEFT *Hand gathered velvet, painted blue*
ABOVE RIGHT *Fabric folded and stitched in a chevron pattern before painting*
BELOW RIGHT *Fabric decorated by the tube-tying method*

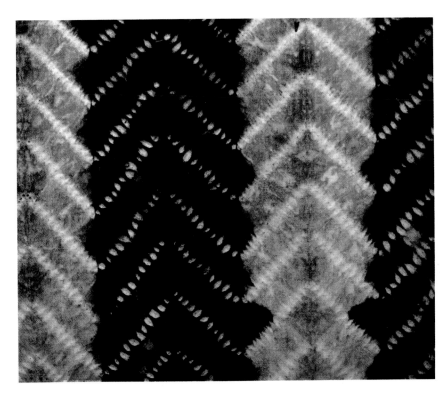

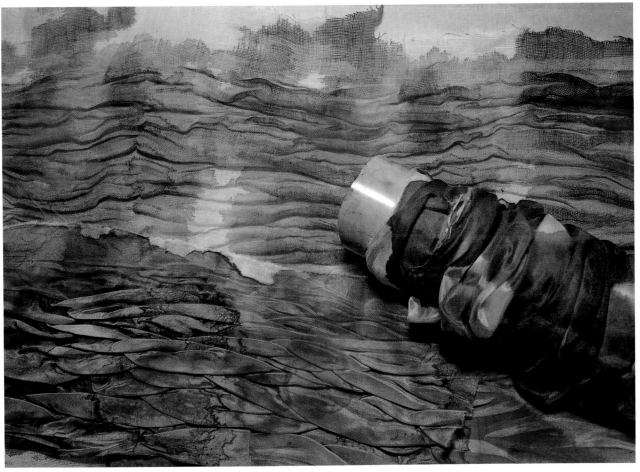

FLICKING AND DRIBBLING

FLICKING

Paint can be splashed on or thrown at fabric to give spontaneous results with great vitality. This is a good method to use with large pieces of fabric as it is speedy. Flicking can be done on plain fabric, fabric already coloured by sponging or rolling, or over a pattern such as masking tape stripes.

Dip a large brush into the paint. Throw paint on to a piece of fabric using jerky movements. Repeat using another colour, up to as many as you wish. It is probably a good idea to place the fabric on a large sheet of plastic on the floor, or even outside on the grass, to avoid covering everything else with paint at the same time. Leave the fabric to dry. Different paints will have different effects on different fabrics, so try them first on small pieces to see the results.

The fabric can be pleated or gathered beforehand to give an interrupted pattern. As fabrics take the colour differently, a fabric can be made by stitching strips of silks, cottons, rayons and synthetic fabrics together, and then flicking on it to give subtle changes of colour across the seams.

WAX FLICKS

Melted wax can be flicked on to a fabric to act as a resist, and the paint sponged or brushed on the fabric when the wax has hardened. Melt some candles, or paraffin wax, in an old pan over a low heat, or in an electric wax pot. Dip an old, large brush into the wax, and flick it on the fabric. Sponge the fabric paint on and leave to dry. Peel off as much of the wax as possible. Then place the fabric upside down on some newspaper and iron the rest off, changing the newspaper when necessary. This will also set the paint. If the fabric is at all stiff, put it in a bucket, add some soap flakes, and pour boiling water over it, stirring all the time. Remove the fabric quickly so that the wax does not have time to settle on it, rinse and dry.

The two methods can be combined by applying wax flicks, then sponging, then, when that is dry, flicking colours over the whole thing.

Paint flicked on a fabric

Wax flicked on a fabric and painted over

Black and white flicked on a grey ground from different directions

DRIBBLING

Colour can be dribbled on a fabric to give meandering lines. Tape the fabric to a board and prop it upright over a piece of plastic or a flat dish. Fill a brush with paint, or use an eye dropper, and drop paint on to the fabric at the top. It can be left to run down the fabric in fairly straight lines, or the board can be tilted at different angles to cause the paint to change direction.

On thin fabrics, thin paints run quite well, but thicker paints on thicker fabrics will not give such good results: try wetting the fabric first so that the paint runs better over the surface.

A resist such as dropped or dribbled wax on the fabric causes the dribbles of paint to change direction without moving the board about. Remove the wax as described on p. 54.

Seams, or pieces of fabric previously applied, will also cause the dribbles to change direction and follow the edges of the fabric.

DROPPING

Thin paint can be dropped on to dry fabric and will dry leaving marks and patterns. A fine silk shows up these subtle patterns better than other fabrics, but try other fabrics to see the difference.

Frame the fabric tightly, either on a ring frame for small trials, or on a square or rectangular frame for larger pieces. Drop the paint using a brush, dropper or syringe with a fine needle. Do not put too much paint on, and let it dry before adding more. If the fabric is slightly damp and a very fine syringe is used, the paint will travel outwards in fine wavy and meandering lines.

LEFT *A design made by cutting up a paper decorated with dribbled paint into triangles, glued to a ground*
ABOVE *Suggestion for a cushion using this design*

LEFT *Red, yellow, green and gold, flicked on calico from different directions*
BELOW *Gold paint flicked on a fabric streaked with fabric paint*

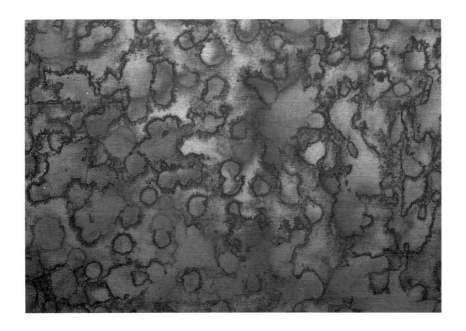

ABOVE *Silk paint dropped onto cotton lawn, ironed while wet and showing the marks of the steam iron plate*
RIGHT *Silk paints were dropped on fine silk fabric and allowed to dry. More paints were dropped on and dried. The stitching was worked with threads painted with the same paints (Christine Cook)*

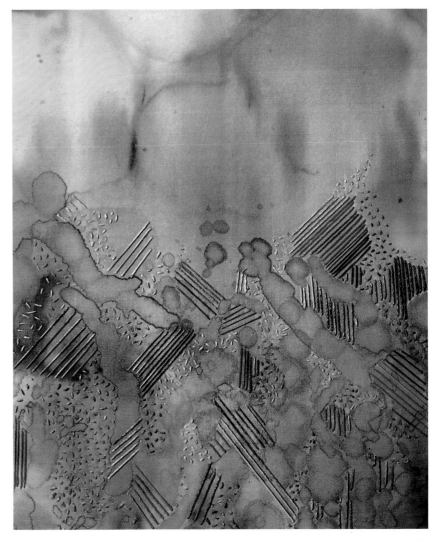

FABRIC CRAYONS

Pentel Fabricfun crayons are made from a soft wax, pigment and binder, and are used to make marks or areas of colour directly on the fabric. They can also be used to make a print, but are not to be confused with transfer crayons (see p. 12). There is a fairly limited colour range, but the colours can be mixed by applying them in layers. These crayons are fixed by ironing in the same way as general-purpose fabric paints, and the colour melts into the fabric so that it seems part of it. They can be applied to fabric which is wet or dry, and made of either natural or man-made fibres.

RUBBINGS

One use for these crayons is for rubbing on fabric laid over a textured surface. Tape or pin the textured piece to a board, lay the fabric over it and tape or pin it to avoid any shifting during the rubbing. Do try multi-coloured rubbings rather than using only a single colour. Stroke the crayon over the fabric in one direction, rather than rubbing back and forth as you would with a paper rubbing, as the crayons can break if treated harshly.

LINE DRAWINGS

Rub the back of a drawing or photocopy using the crayons, using either one or many colours. Tape a piece of fabric to a hard board, and place the photocopy crayon side down on the fabric. Tape to secure. Using an old ballpoint pen, draw on the design lines, transferring the colour to the fabric. This is more interesting if the fabric has been rolled, printed or otherwise coloured beforehand.

MARK MAKING

These crayons can be used for making marks directly on the fabric by drawing continuous or broken lines, dashes or dots. Notches can be cut in the crayons to make different marks. Other marks can be made by pushing, twisting or rocking the crayon as you draw. These marks can be used to build up a design on the fabric, perhaps on a fabric that has previously been sponged in different colours.

GRATING

Shave or grate the crayons on to fabric. Place silicon paper (baking parchment) over the top and iron over it to melt the crayons into the fabric.

PRINTING

Rub crayons over the back of leaves or anything else that is flat. Place the leaves crayon-side down on a fabric, cover with greaseproof paper, and iron to melt the crayon into the fabric.

EDGE PATTERNS

Using a template or stencils, rub the crayon off the edge of the template on to the fabric to give a misty halo around silhouettes. If using a template, the halo will be on the outside of the shape; if using a stencil it will be on the inside. This can be done on fabric which has previously been printed with similar shapes, or patterned with masking stripes.

A small drawing showing some of the marks that can be made using fabric crayons

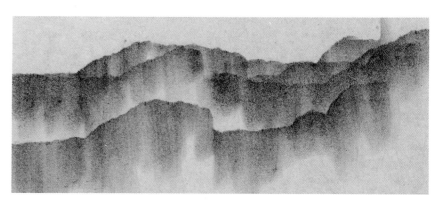

An edge design made by rubbing fabric crayons off the edge of a piece of paper on a fabric

\mathcal{F}ABRIC PENS

These come in the form of felt-tip pens, some with a fairly fine point, some with an angled tip to give a wider line. Javana Marking Pens and Colour Fun pens are thrown away when used up, but Pebeo Setaskrib are refillable when empty. There are also spare tips available for this brand. All brands are (so far) fairly similar to use. The colour range is fairly small, but can be extended by mixing the colours on the fabric.

Pens can be used on wet or dry fabric, and are suitable for most types. They are ironed to fix the colour and are very convenient to use, but the results can be crude, so try them out on small pieces of fabric first.

DOTS OF COLOUR
One use for these pens is to build up shapes, patterns or areas of colour, using different colours together. From a distance the eye blends the colours, but the effect is more textural than with paint.

LINE DRAWINGS
These pens are excellent for drawing detail and linear patterns, and make a good contrast to other methods of colouring fabrics, such as printing or discharging. Parts of the drawing can be filled in with hatching or cross-hatching to give tone, texture, and to mix colours. They can be used to give a strong firm line, or gently stroked, rolled or pushed to give a gentler one.

BLENDED EFFECTS
When used on wet fabrics, especially if the side of the pen is used, the colours will gently flood and merge into each other, giving a very soft result.

EXPLOITING THE WEAVE OF A FABRIC
When these pens are stroked over the surface of a strongly textured fabric such as corduroy, or a coarse weave such as hessian, they emphasize the nature of the fabric because the colour sits on the surface.

METALLIC PENS
Fine, medium and broad nibbed metallic felt-tip pens are available. Although not designed specifically as fabric pens, these are often used on fabrics. They are fast to light, although not to too much washing, and are very convenient to use, especially on dark colours.

A drawing on fabric using fabric felt pens. Areas of this could be emphasised with french knots or seeding

Black cotton flicked with bleach, then fabric crayons were grated on it and melted in with an iron

Black velvet bleached using a one-stroke brush, rubbed gently with fabric crayons to give the colour

RIGHT *A design based on an illustration in the* Book of Kells. *Gesso was rolled on to a fabric, then paint was rolled on the back and on the front of the fabric. A piece of paper was totally covered with red fabric crayon and drawn through to transfer the red lines to the fabric. Broken lines were added with a fabric pen. This piece will be further embellished with applied transparent fabrics, running stitch and couching (Thina Halmos)*
BELOW *Detail of a noticeboard with lettering using fabric crayons, reinforced with machine stitching (Linda Rakshit)*

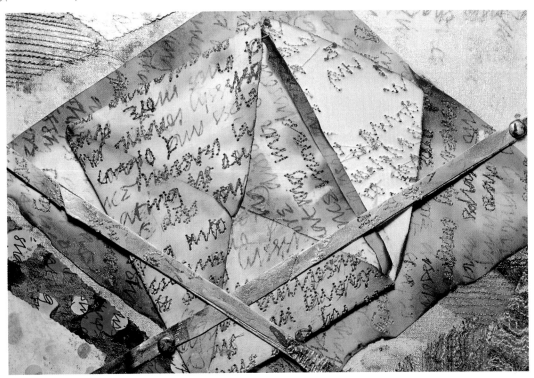

SCRUNCH SPRAYING AND PAINTING

SCRUNCH SPRAYING

This method produces a marbled effect, using spray paint in cans. Car spray paint is the most easily available, and has reasonable fastness to light and careful washing. There is also a spray paint which flower arrangers use on ribbon, which is more difficult to find. Both can be used on fabrics made from natural or man-made fibres, and need no fixing. Dampening the fabric first makes nice clear folds when it is crumpled; if the fabric is left dry, a different, much softer, effect is obtained.

Dampen the fabric by spraying with water, and crumple it loosely into a ball. Spray it with paint from the side. Open it out. Re-crumple it into a different form, and spray it again with a different colour. Allow to dry. To avoid spray paint going where you do not want it to, prop up some old newspapers against cardboard cartons arranged in a V-shape, and spray into the corner. Always spray lightly, as car paint can easily look heavy and stiffen the fabric too much.

SCRUNCH PAINTING

Dampen the fabric as before and crumple it loosely. Dab paint on it using a large brush or sponge with a very little general-purpose paint on it. Allow to dry. Iron to fix. Repeat with a second colour.

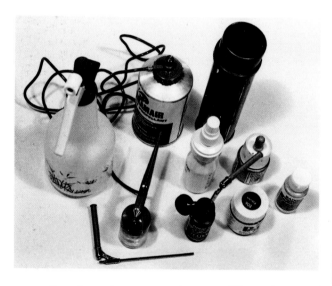

ABOVE *Spraying equipment – a garden spray, diffuser, air gun and compressed air, diffuser in bottle of fabric paint, car spray paint, and a plastic spray bottle*
ABOVE RIGHT *Scrunch spraying*
RIGHT *Scrunch sprayed fabric when flat*

\intPRAYING

Spraying fabric paint or Procion dyes can result in a very smooth layer of colour, or a textured look, owing to the mass of many tiny dots. The most professional method is to use an airbrush, but these are rather expensive and a problem to keep clean. An air-gun is much cheaper and will spray large areas quickly. The traditional method is to use a mouth diffuser, one end of which is placed in the paint, and the other end in the mouth. It is directed straight at the fabric and the plastic mouth-piece blown into. Some cheap, easily available diffusers are very difficult to use, but more expensive Lefranc and Bourgois diffusers are now available and are no trouble at all. Alternatives are garden sprayers for large quantities of paint, or small perfume spray bottles.

Use a thin fabric paint, such as a silk paint, or one of the special fabric paints made for spraying, such as Pebeo Set-Air, or Deka Perm-Air, or the Badger airbrush paints which come in small bottles with a hole in the top that the diffuser just fits into.

Spray lightly, as it is easy to spray too hard, when the paint will be too wet and run down the fabric. Pin or tape the fabric to a board covered with plastic, and prop it up so that it is vertical and the spray is horizontal. If you do not, then the bottle will tilt and the paint drip out, and drops will fall from the spray on the cloth. If you have a large piece to spray, pin or tape it to the garage door or to a clothes line on a windless day. Dry the fabric and iron it to fix the paint. Fabric can be sprayed simply in a variety of colours, which will mix where overlapped, or the spray can be resisted in some way such as by using paper templates or stencils, through mesh or lace fabrics, any method of waxing, or a paste resist.

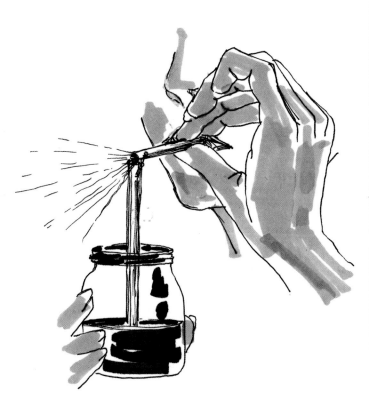

How to use a diffuser

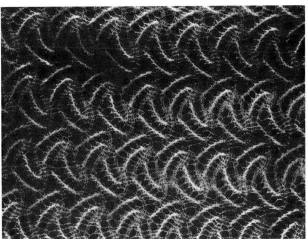

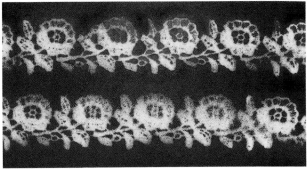

Spraying through lace and fabric

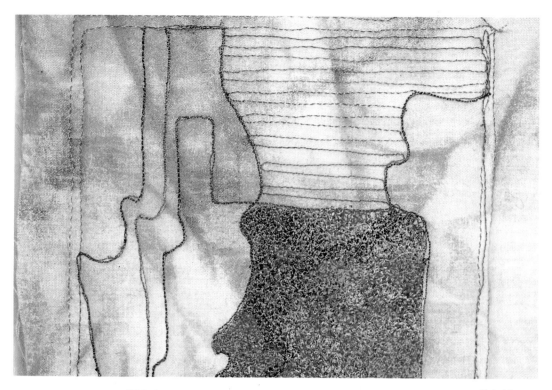

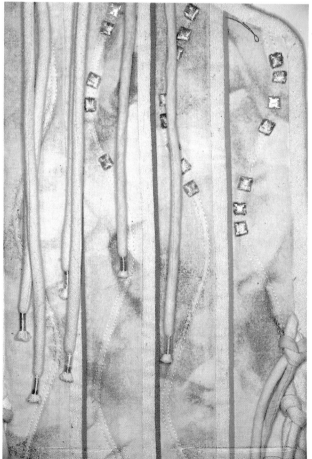

ABOVE *Stitching on scrunch sprayed fabric, carrying the background colour through the stitching*
LEFT *Front of a jacket made with scrunch sprayed fabric*

Pleated fabric. The pleats were pressed in one direction and it was sprayed with red and blue car paint; then pressed in the other direction and sprayed gold

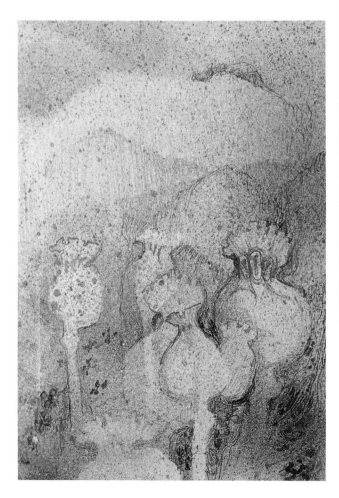

Sprayed design using paper masks, with added drawing (Val Du Cros)

\mathcal{S}TENCILS

Stencilling is a quick and easy way of transferring a simple image to fabric to build up patterns or borders. Use a design that is made up of simple shapes that are not too small, or too tightly curved. Designs with small disconnected shapes are ideal for this method. Enclosed shapes that you wish to retain must be connected to the outside edge of the hole with bridges to stop it falling away.

A stencil can be cut from paper, thin card such as a cereal packet, stencil card, flexible acetate or low tack masking film. Transfer your design to the card by placing a piece of carbon paper face down on it, and the design on top of that. Tape both pieces to the card to stop them shifting. Draw the lines of the design with a biro and remove the papers. If you are using acetate, place it over your design and trace it using an overhead projector pen.

Lay the card on a cutting board, a chopping board or an old thick piece of card. Use a small knife to cut out the shapes with – a 'Stanley' disposable craft knife is good, as it is very flexible and will go round, so that each cut is smooth. To make the paper or thin card waterproof, spray it with car spray paint on both sides. Two coats should be enough.

Tape a piece of fabric to a board or plastic-topped table and mark where the stencil pattern is to go using a water-soluble pen. Lay the stencil on the fabric. Dip a stencil brush into a saucer of general-purpose fabric paint and scrape most of the paint off again on the edge. The brush must be nearly dry when applied to the stencil, otherwise the colour will run under the edges and blur the pattern. Lightly dab the paint over the holes in the stencil. Move the stencil to another part of the fabric, not allowing it to touch the wet paint, and dab with more paint. Leave to dry. Another colour, or a different stencil, can be placed over the first pattern and more colour added. Two or three colours can be dabbed into each space. Dry and iron to fix.

Car spray paint is wonderful to use with stencils because you can get such delicate effects and colour mixes, and it dries so quickly that you can build up layers of colour without waiting. Alternatively, use fabric paints specially made for spraying. When spraying colour through stencils, the board should be propped upright so that any blobs from the can fall on the floor rather than on the fabric.

You can fill the stencil shapes in or draw around the edges with fabric felt-tip pens or fabric crayons; you can dab starch resists or bleach through the holes; or you can spatter colour across using an old toothbrush and a knife. Stencils can also be used for rubbings. Place a piece of smooth fabric over the stencil and rub with fabric crayons. Or rub on paper using fabric transfer crayons and then iron it on fabric.

Stencil patterns look more interesting if the fabric has already been coloured by sponging, spraying, rolling or any other method in this book, to build up layers of colour, texture and pattern.

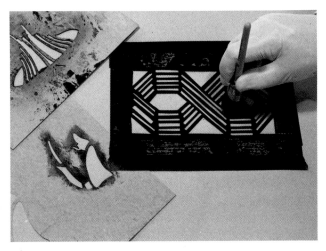

Dabbing dry paint through a stencil

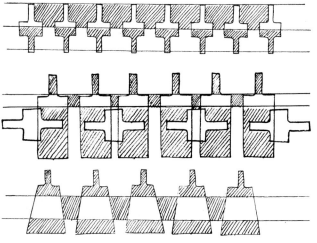

Patterns made by drawing through a stencil

\mathcal{S}CREEN PRINTING

Screen printing is up-market stencilling, where the image is printed by pressing paint through a stencil which is attached to a fine mesh stretched on a rigid frame. The stencil can be of paper, film, wax, Indian ink, drawing gum, various fillers (blocking mediums), or flat objects such as leaves or feathers. Screen printing is more versatile than any other method, and many prints can be taken from each stencil.

SCREENS

Any wooden frame can be used, but it should be varnished first to make it waterproof. Allow it to dry before attaching the mesh.

Use fine nylon or terylene mesh and wet it before stretching it on a wooden frame so that it shrinks when dry and remains taut in use. Attach it to the frame with drawing pins or staples, using many more than you think necessary to ensure that the fabric is drum tight. Stretch the fabric really tight all along each side, pinning as you go. When the fabric has dried, seal all edges where the mesh meets the frame. Start on the bottom (the flat side) and lay a strip of masking tape along each edge, overlapping at the corners. Turn the frame over, and lay another strip along

Pressing paint through a screen with a squeegee

each edge, bending it in half so that it forms a right angled seal of the narrow ends of the frame, lying it flat on the fabric and overlapping the first strip. This makes a well for the fabric paint to sit in.

SQUEEGEES

The fabric paint is forced through the screen using a fabric printing squeegee, or a window cleaning squeegee (printing blade).

FABRIC PAINT

Fabric paint for screen printing should be rather thick, so silk or diluted paints are not suitable. Paler colours can be achieved by adding extender medium, which also makes them more transparent. It must not be allowed to dry on the screen as it will be impossible to remove, so continue printing without a break until finished, and then immediately wash the screen under the tape, scrubbing it with a brush to remove every particle. Screen cleaners are available if there is a problem.

PAPER STENCILS

Cut or tear thin paper into strips or shapes and lay them on the fabric that you will print on to. Remember that the paper shapes will resist the paint and only the spaces in between will print. Good papers to use are newspaper, greaseproof paper, tracing paper, or layout paper. Acetate film can also be used, and will last through many more prints than paper stencils. If a design has been planned using different colours, a separate stencil will have to be made for each colour. Cut an L-shape in each corner of one stencil just outside the design area. Then cut this same shape in the corners of all the other stencils, in exactly the same place. The paint will print through this and mark the fabric so that each succeeding stencil can be placed in the right position. The first stencil is placed on the fabric, the screen laid flat side down on top of it, and the paint pressed through the mesh. The paper will then be attached to the mesh, and further prints can be made. This stencil is removed, the second stencil laid on top of the dried fabric, matching the corner marks. The screen is laid on top, and the paint pressed through as before. Once the paper stencil has been removed from the screen it cannot be used again.

Patterns made on ABOVE *papers and* BELOW *fabric by spraying through a stencil, with added pintucks and quilting*

ABOVE *Screen print of drawing on page 58 (Joan Powell)*
RIGHT *Screen print made through a wax rubbing on the screen of a wood block.*

BLOCKING MEDIA

There are various types but they are applied directly to the flat side of the screen to resist the paint. They can be carefully painted around a pencil drawing, dabbed or flicked on to the screen, or block-printed on. Allow to dry naturally in a horizontal position before use. The Hunt Speedball screen filler can be removed by applying neat liquid detergent to both sides of the screen. Leave the screen flat side down for 15 minutes, and then scrub with hot water. Rinse with hot water, scrub with a brush and scouring powder, and rinse again. Other fillers come with instructions for their removal. Many prints can be made from these screens, but eventually the medium gets worn away in areas of fine detail, and the prints will change.

DRAWING FLUID

Drawing fluids are applied with a fine brush to the flat side of the screen. First trace a drawing on the mesh using a pencil, and paint the fluid over the lines. This fluid can also be applied in other ways, such as dribbling or flicking. Apply the fluid as thickly as you can, and allow to dry naturally. When dry, apply screen filler, using a coating trough or a squeegee, over the whole screen. This must be applied quite thinly. Allow to dry. Hunt Speedball drawing fluid is removed by holding the screen under running water until the blue fluid dissolves, leaving clear areas or lines surrounded by the screen filler which has not dissolved. Pebeo liquid frisket, an equivalent product, is removed with a crêpe rubber. Always refer to the manufacturer's instructions, as products differ and new ones keep appearing.

WAX

Wax crayons, candles or melted wax can be used as a resist on the mesh. Wax crayons or candles can be used to draw on the flat side of the screen, or can be used to make rubbings, textures or patterns in the normal way. Melted paraffin, or batik wax, can be applied with a brush or a tjanting, or it can be printed on the mesh. As soon as the wax has hardened, it can be used. It is removed by pouring boiling water through it into a bucket, which is then emptied at the bottom of the garden, *not* down the sink. Or the screen can be placed flat side down on a wad of newspapers and the wax melted on to the paper using a hairdryer. Keep replacing the paper until there is no more wax. Squeeze some liquid detergent on to the screen, brush it all over, and then pour boiling water over the mesh while brushing with the other hand to remove the final tiny particles of wax.

PRINTING

Place the piece of fabric on top of some newspapers, and lay the screen on top. Using a teaspoon or a plastic garden label, drop a thick line of fabric paint along the strip of tape at the narrow end of the screen. You will need more paint than you think, but what is not used will be saved for the next print. Using a squeegee which is slightly narrower than the frame, pull the paint from one end of the screen to the other, holding it at an angle of about 45 degrees. Press the paint through the mesh on to the fabric, holding the squeegee with both hands. Do not stop in the middle of the pull. Then return the ink to the far end of the screen, again holding the squeegee at an angle. Raise one end of the screen and prop it up on a jar or tin. Remove the piece of fabric.

When printing larger pieces of fabric, they are best pinned to the work surface as follows: cover a table or a large board with a blanket, stretched tightly and tacked or stapled to the surface. Cover this with a sheet of PVC or vinyl, also tacked to the table. Cover this with an old piece of cotton, which absorbs any excess paint, pinned to the PVC around the edges with sewing pins. Then pin your print fabric to this around all four sides. Surplus fabric can be left hanging over the edge. Print all the colours you need before unpinning the fabric, as it will be impossible to replace it in exactly the same position. Dry the fabric and heat fix the paint as usual.

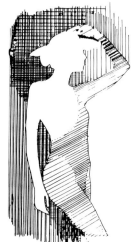
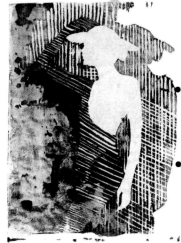

LEFT *Drawing from an advertisement (Elizabeth Nourse)*
RIGHT *Photographic screen print based on the drawing. Many of these will be printed and stitched together to make a quilt (Elizabeth Nourse)*

PHOTOGRAPHIC SCREENPRINTING

This is a new process which enables photographic screen printing to be done at home without a dark room, and can be used with water-soluble fabric paints. Prepare the screen as before, using a synthetic mesh. Key the screen and roughen it slightly on both sides to accept the emulsion using a soft brush and scouring powder. Rinse and dry thoroughly.

The design must be transferred to clear acetate. This can be done using Indian ink or a photocopier. Make sure the design is solid black in areas where you wish to block the light out. It is possible to have a positive and a negative image of the same design so that part can be printed in one colour, and the rest of it in a second colour. This can be done on a colour photocopier.

SENSITIZING THE SCREEN

Pour 20ml (four teaspoonsful) emulsion into a 25ml medicine pot (from a chemist). Add 5ml (one teaspoonful) sensitizer and stir gently but thoroughly to mix. This quantity is enough for two (25cm × 35cm) 10in × 14in screens. Pour a little of this emulsion along the tape at one end of the screen. Using a coating trough, or a squeegee, scrape the emulsion across the screen, holding it at an angle of 45 degrees. Scrape hard to leave a very thin, even, coating of emulsion. Scrape off any excess. Turn the screen over and scrape the other side until it is equally thin. Any excess emulsion can be stored for several days in a fridge in a covered container that seals out the light. Wash the squeegee in water.

Place the screen to dry in the dark in a drawer, cupboard, or under a box, leaving it flat side up and horizontal. It will take some hours to dry naturally and can be left overnight. If you wish it to dry more quickly, place the screen with a fan heater in a dark cupboard and shut the door. Leave the screen in the dark until it is dry (you can check this by looking at it once or twice without harm).

EXPOSING THE EMULSION

Place a sheet of black paper on a table. Arrange a no. 1 photoflood bulb with a metal reflector (a disposable 25cm (10in) or 30cm (12in) aluminium foil pie plate can be used as a reflector) about 42cm (17in) or 45cm (18in) away from, and centred above, the paper. (A 150 watt bulb may be used instead, but the exposure time will be trebled.) A photoflood has a hot spot in the centre of the bulb, so suspend a small tin lid about an inch away from the centre. Do this by taping thin wire to the edge of the lid and taping the other ends to the reflector.

Place the screen flat side down on the black paper, the acetate design on the mesh, and a piece of glass on the acetate to hold it flat and in contact with the mesh. Expose. The timing of the exposure is not critical, and can be from 12 to 16 minutes, according to the thickness of the emulsion. You will see the pattern as a paler green.

Wash the screen on both sides under tepid water to remove exposed emulsion. Final fragments can be loosened with a toothbrush. Dry before using. If you wish to remove the emulsion from the screen it must be done within a few days. Mix one part bleach with two parts water, and pour this on to both sides of the screen. Leave flat side up for three or four minutes and then wash off using hot water. Finally, wash with liquid detergent and a soft brush. Rinse and dry.

A positive and a negative version made from the same original photograph of a pile of stacked chairs. Each of these was exposed on a screen so that they could be printed one after the other on the same piece of fabric, each one in a different colour so that the white areas in the left could be green, and the white areas in the right could be red.

White silk screenprinted with pink and blue paint. The design was based on a blown ink pattern. It was overprinted with yellow using the same design as in the example on the right (Vivien Prideaux)

Screen print using Pebeo Brod Express. The design was based on shadows on water (Vivien Prideaux)

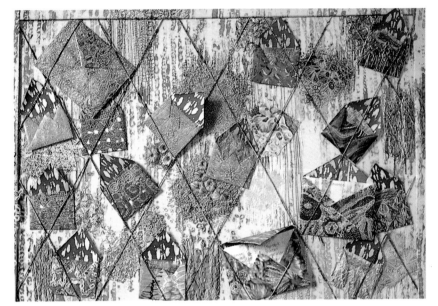

A noticeboard and detail based on a study of chain stitch in foreign and historical embroidery. An enlarged photocopy of chain stitch was made, transferred to a screen using the photographic method and printed on the background fabric. Variations of chain stitch were worked on the fabric. All the notes and drawings made during the research are contained in the envelopes which are made from coloured photocopies of some of the embroidery (Linda Rakshit)

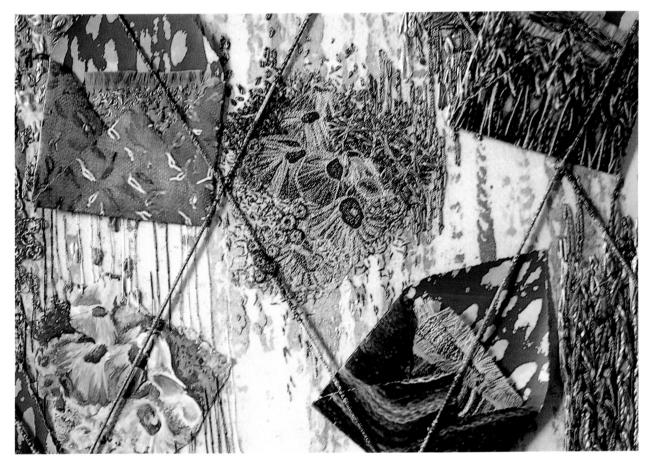

PRINTING WITH BRUSHES

There are many different shapes of brush available: pointed, flat, fan-shaped, mop-headed, wedge-shaped, round stencil brushes and specialist brushes such as the one sold for dragging, which has five small separate brushes attached to a handle. Also, you can cut your own brushes to give yet more shapes. These will all make different marks on the paper or fabric: this can be a drawing, or a simple or complex pattern. Just dip the brush into paint, scrape off any excess, and press the brush gently on to the fabric. The face, the side and the end of a brush will all make different marks. As well as printing, a brush can be rolled, dragged or twisted to give yet more marks. If the paint is wet, the marks will diffuse, so if a definite mark is wanted, use very little paint. It is worth experimenting on an unwanted piece of fabric just to see what the brush will do, and how many different marks it can make.

Two drawings using brushes, combined with pens, in black ink and white paint (Joan Powell)

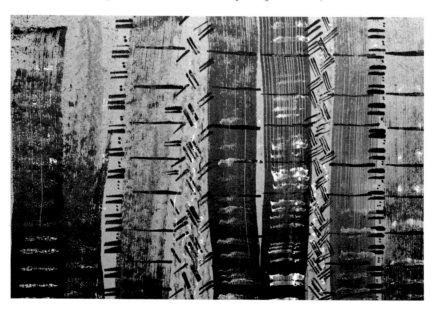

A drawing of a woven basket using a one-stroke brush in black ink and white paint on grey paper

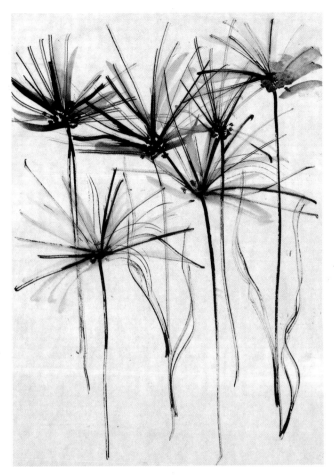

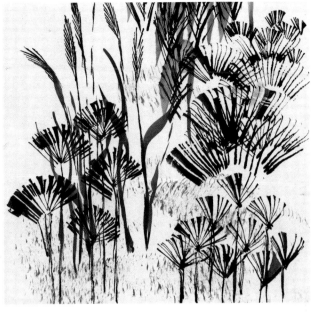

Two drawings of flowers and seed heads using one-stroke (flat) brushes (right) and a flowerstem dipped in ink (left), and two prints using fan-shaped brushes, one in white paint on grey paper, and the other printed with wax and then painted

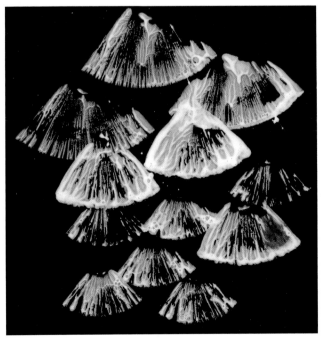

Jat 1 and Jat 2. Two panels based on kimonos using large brushes to make marks on the fabric, with added stitching (Yvonne Morton)

Opaque paint applied with a one-stroke brush on a sample of stitching and slashing through several layers of painted and sponged fabrics

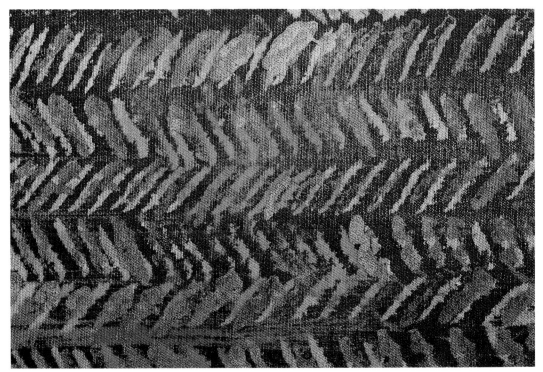

Bleach applied to discharge fabric using one-stroke brushes, and gold paint added using the same brush

CARD PRINTING

Any type of card can be used to print with, using the edges straight, curved, or rolled. Plain card can be used to print straight lines, or can be scraped across the fabric to give bands and areas of thin colour. Corrugated card produces recognizably wavy prints, and the ends of matchboxes print rectangles. Short pieces of card can be used to build up chevron and basket patterns, and shapes can be cut from card to make blocks.

Either dip the card edge into fabric paint rolled on a glass plate, or apply the paint to the edge with a brush. General-purpose paint is the one to use for this method, as thin paints will not print as well.

The card will eventually become soggy, but it is easy to cut a new piece.

PULLED CARD PRINTS

Apply fabric paint to a piece of card lying flat on the table. Lay a second piece of card the same size on top, and press firmly all over with your hands, or rolling a roller back and forth a few times. Lift the top piece of card carefully from one corner and pull it away from the underneath one. This produces a pattern on both pieces of card which are then laid, paint side down, on fabric.

More than one colour of paint can be applied to the card, and the colours will mix slightly during the process.

MONOPRINTS

One way of producing monoprints is to cut nicks and wedges into the edge of a piece of card. Roll fabric paint thinly on to a piece of glass. Using the cut edge of the card, scrape it across the paint to leave a pattern – lines all in one direction, curves, or multi-directional lines. Then lay a piece of fabric on top of the plate and gently roll it with a clean roller. Dry and fix. Sometimes it is possible to obtain a second print, but it will be paler and less distinct.

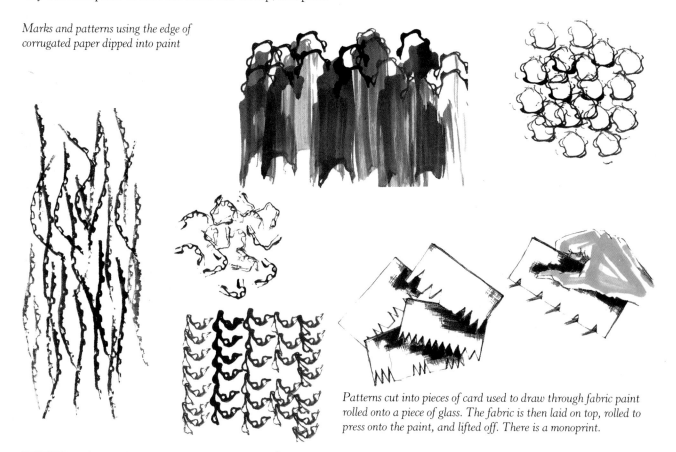

Marks and patterns using the edge of corrugated paper dipped into paint

Patterns cut into pieces of card used to draw through fabric paint rolled onto a piece of glass. The fabric is then laid on top, rolled to press onto the paint, and lifted off. There is a monoprint.

\mathcal{P}RINTING WITH CARD BLOCKS

Satisfactory cheap printing blocks can be made by cutting shapes from a thick piece of card and gluing them to another piece. As fabric paints are acrylic based, a protective coating is built up over the block, which then lasts a surprisingly long time. Card blocks made from torn strips or shapes of smooth or corrugated card are interesting, but care is needed when applying the paint so that it does not cover the background areas as well as the pattern shapes.

Designs for card blocks should look like stencil designs, with separate shapes and spaces between them. Transfer your design to a piece of mounting card using carbon paper. Cut it out carefully using a craft knife. Glue the shapes to another piece of thick card (or to a softwood block, which will be easier to hold). Make a handle from

sticky tape and apply it to the back of the card block. Trim all excess card away from the edges of the design, so that you can see where you are placing the block. Mark the back with a cross at the top right-hand corner. Tape or pin the fabric to a board previously covered with a thick layer, or, even better, two layers, of cloth (an old piece of blanket will do). The fabric should be reasonably taut, and the surface should give slightly when you press it.

There are two methods of applying the fabric paint to the block. One is to roll the paint thinly on to a glass plate, then to press the block into it, and then on to the fabric. Another is to paint the block with a brush: the advantage of this method is that each print can be made of more than one colour, but it is slower.

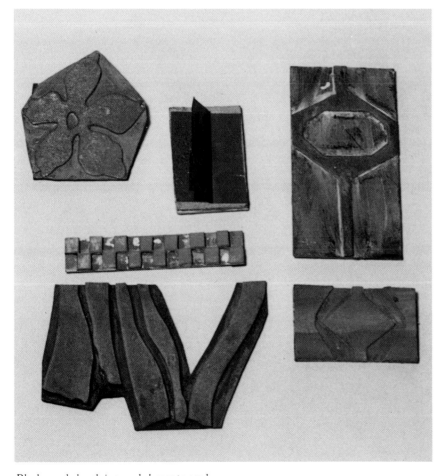

Blocks made by gluing card shapes to card

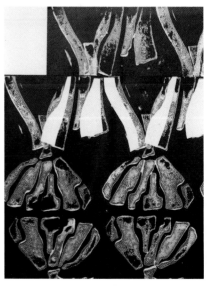

Design for a cushion made by printing with card blocks

63

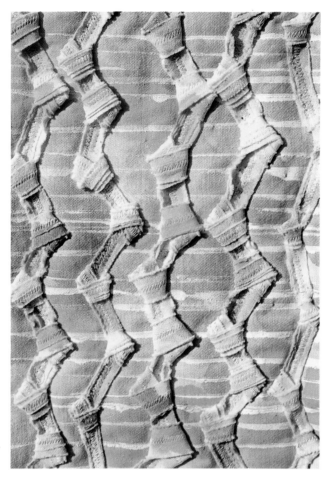

LEFT *Strips of fabric stitched together in layers, knotted and stitched to a background fabric printed with card strips. Very pale colours were then flooded over the whole piece*
BELOW *Strips of card dipped into paint and scraped along a fabric*

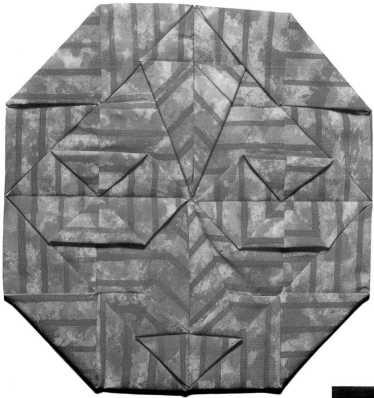

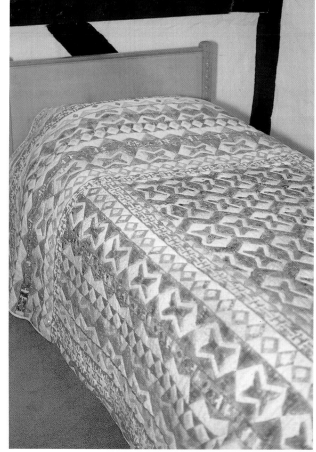

ABOVE *A version of cathedral window patchwork made of fabric first sponged and then printed with the edges of card (Shay Gillard)*
RIGHT *A quilt using fabric quilted with card blocks. The block was painted with red, yellow and blue fabric paint and printed on a fabric that had been sprayed with the same colours. This method of printing gives a multi-coloured effect all in one go (Jean Philpott)*

ℬLOCK PRINTING

A 'block' is any object with a patterned or textured surface which is covered with paint, ink, wax or bleach and pressed on to the cloth to leave an impression.

The block can be carved from wood, rubber, cork, lino or a potato. It can also be made by using pieces of card, felt, string, metal strips or nails, or any other substance glued to a thick piece of card or wood.

Many found objects can be used to print with, for example a leaf, flat pieces of fruit or vegetables, or tools and equipment such as screw heads, potato mashers, forks, or coiled pieces of wire. A good search round your kitchen or toolshed will result in many printable finds.

Block printing is a quick way of producing pattern, either borders, spot patterns or all-over patterns, first on paper to try out ideas, and then on fabric as a base for stitching. Areas of texture can also be quickly produced either by using a textured block, or by building up layers of overlapping patterns in different colours using the same or different blocks. Designing by block printing is excellent for trying out different layouts and colourways.

Here are some suggestions for blocks:

Sponge – cut pieces of sponge, natural sponges, or commercial sponge blocks.

Rubber stamps – carved erasers, or commercial rubber stamps.

Potato – carved to give different shapes or patterns.

Wood – if hard wood is too difficult to cut, try balsa wood which can be cut with a craft knife, dowel, sticks with the ends cut into shapes, matchsticks glued to card or found pieces of wood with interesting shapes or surfaces.

Card – use 6 or 8 sheet card and glue to another piece of card. Trim close to the pattern and add a handle made of sticky tape. Also try matchbox covers, the edge of a piece of card, and corrugated card.

Polystyrene – cut into, or with melted lines made with a heated knitting needle.

Metal – mesh, machine parts, screw heads, washers glued to a cork, forks, or nails driven into a cork.

Fabric or paper – flat or folded textured fabrics, canvas or paper glued to a piece of card, or scrunched into a ball, dipped into paint and dabbed on to another fabric.

APPLYING PAINT

The paint must stick to the surface of the block, so the thicker general-purpose fabric paint is the best to use. It can be painted on the block using a large brush, or rolled on a sheet of glass or acetate and the block pressed on the paint and then on the fabric. The advantage of using a brush is that two or three colours can be applied to the block, although this takes longer. When using a large block, the paint can be rolled directly on to it.

Lay the fabric on a thick wad of newspaper, or newspaper over a thick blanket, to give a resilient surface to print on. Do not use too much paint, as the results will look heavy and the image will clog up; nor try to achieve a perfectly smooth result, as this lacks charm and looks too commercial.

EXPERIMENTS

- Try printing on to fabric that has been sponged, streaked, rolled or marbled.
- Print the same pattern on different fabrics such as satin, cotton and a transparent fabric, and use them together in the finished piece of work.
- Print before and/or after gathering, folding or pleating the fabric.
- Print areas with a block cut into the shape of a stitch, and then work the stitch on top of it.
- Print on strips of different fabrics which are then woven or stitched together.
- Print on evenweave fabric and reinforce or echo some of the shapes or patterns with darning or blackwork.

Prints made from a carved wooden block bought in India

LEFT *A selection of wooden blocks and printing sticks*

BELOW *Patterns suitable to carve into wooden or polystyrene blocks, or made of card, or to cut from stencils. Different parts of the insect can be used to make borders and patterns*

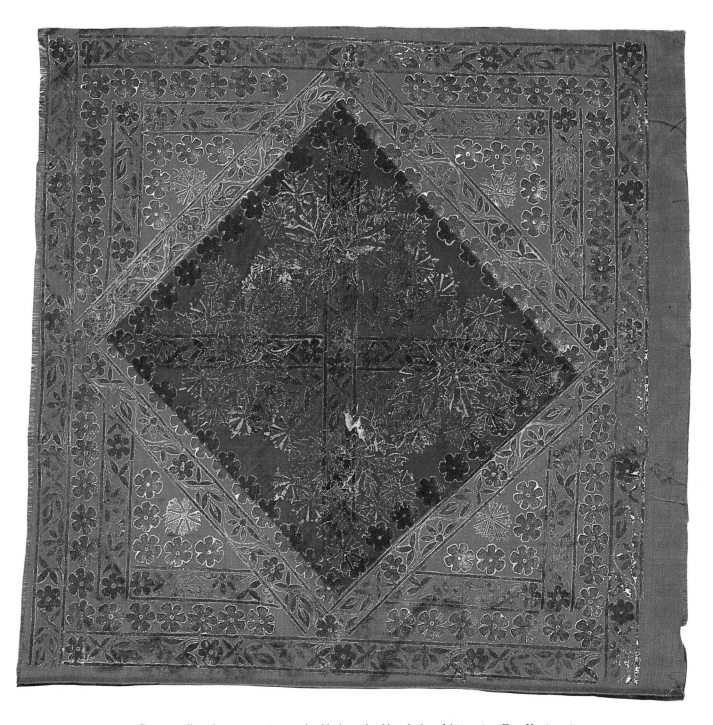

Print on silk and organza using wooden blocks and gold and silver fabric paint (Ewa Kuniczac)

ABOVE *A string block and the print from it*
BELOW *Variations in the placing of this carved wooden block to build up borders, and the finished print using black fabric paint on silk noil, nearly covered with straight stitches using silk threads, but letting the print show through (Ros Chilcot)*

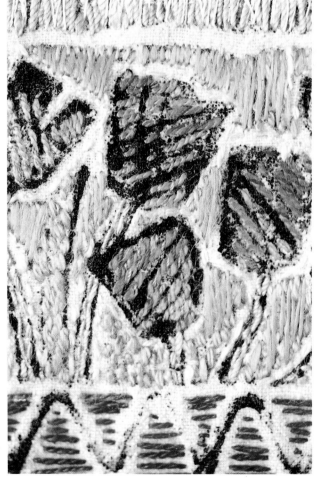

\mathcal{P}OTATO PRINTING

Potato printing is a very much under-rated method, which is a pity, as it is quick and fun, and the results are beautiful. A large potato is cut in half with a long knife to leave two smooth faces. Cut your design from paper, lay it on the potato and draw round it with a sharp point. Remove the paper and cut the design with a craft knife or small kitchen knife for straight edges, and a spoon for the curves. For intricate details, use lino cutters. Cut and dig the parts of the image that are not to be printed deep enough to give a sharply defined image when printing. Cut a new potato for each colour in the design.

Allow the potato to dry slightly before using, or dab it on a paper towel to get rid of excess moisture. Lay the fabric over a wad of newspapers or on an old blanket to give an absorbent surface while printing.

The thicker fabric paints are the best with potatoes, or use acrylic paints slightly watered down. Gold paints print very well with potatoes. Apply the paint to the cut edge of the potato with a flat brush, and press it on the fabric. More than one colour can be used at the same time, and the printing can be done on a fabric that has already been decorated by some other means.

LEFT *Some of the shapes a potato can be cut into*
BELOW *How to print a mitred corner. Mark a right angle along two edges of the corner. Lay a piece of scrap paper diagonally across the corner. Print right in the corner first and then move away from it, printing along the marked line. The part of the block not needed at the corner is printed on the paper and is discarded When the paint has dried, lay another piece of paper diagonally across the corner covering up the first print. Mark on the paper the point in the corner where the point of the first print is, and print with the corner of the pattern touching it. Then print outward from the corner along the marked line*

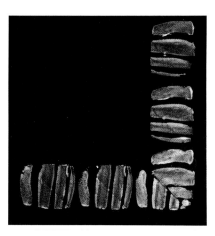

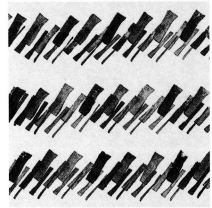
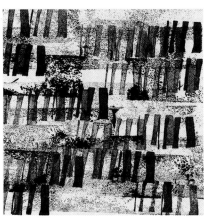
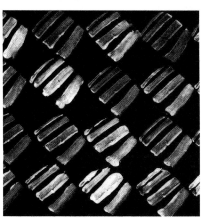

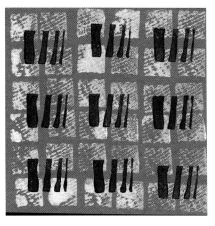
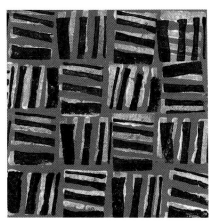
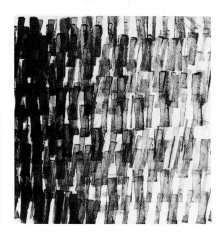

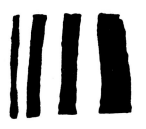

Some of the patterns that can be printed using the carved potato block shown at the bottom of the page

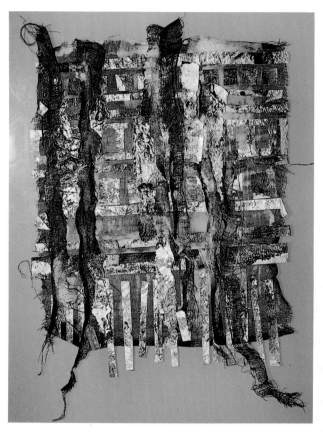

A panel using potato printed organza, muslin and silk

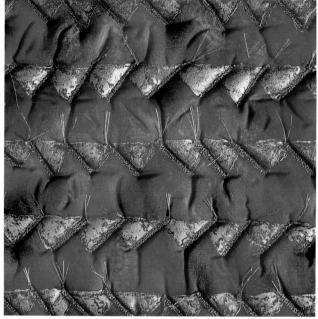

Potato printed silk, quilted and tied knots using fine gold thread (Christine Cook)

\mathscr{P}RINTING WITH OBJECTS

Cauliflower prints outlined with gold pen and areas filled in with gold paint (Sue Kerry)

Print using the end of a dowel rod, with shi-sha and cretan stitch

Many objects can be dipped into fabric paint and used to print on fabric. It is worth trying corks, which can be cut into shapes or patterns; combs and forks; bolts, washers and screw heads; leaves and seedheads; crumpled paper; cut slices of shells; and dowel rod and stick ends, which can be cut into to give different marks.

Roll the thicker, general-purpose fabric paint on to a glass sheet, or soak a piece of felt in the bottom of a dish with paint. Press the object into the paint, and then on the fabric. Usually two or three prints can be made before the paint needs to be renewed, and the change of tone obtained as the paint runs out is more interesting than a perfect print every time.

Simple or complex patterns can be built up printing like this, or a more diffuse effect achieved by overlapping prints at random in many layers, each layer a different colour or tone.

Print using a plastic button, piece of card and a door stop

Print using the end of a small stick (Linda Rakshit)

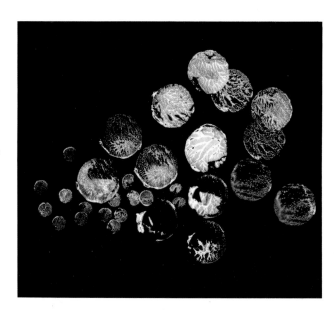

Print using the end of a dowel rod

\mathcal{R}UBBER STAMP PRINTING

There are commercial rubber stamps available now, mostly through mail order, and the Yellow Pages list firms who will make rubber stamps to your own design. Alternatively, you can cut your own from pencil rubbers which, although small, are wonderfully easy to cut into and to print with.

Commercial rubber stamps are made from ridged rubber shapes and patterns glued to a plastic or wooden block. They are made for use with inks and the ridges are sometimes too shallow to print well with fabric paint, so try a thinner silk paint. Metallic paints can build up a thick layer on these stamps which will spoil the print, unless it is well washed off each time.

Rubbers that you cut yourself can be bought quite cheaply and carved easily with a craft knife. A different pattern can be cut into each of the four edges, and another one on the larger face. They take the paint extremely well and will last indefinitely.

Roll the paint on to a glass plate and press the stamp into it, or apply the paint with a brush. Press the stamp on to the fabric, taped or pinned to a board previously covered with one or two layers of blanket. If printing on very small pieces or strips of fabric, newspapers can be used as a base.

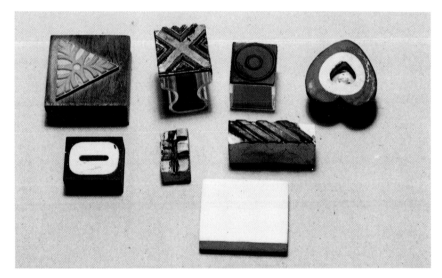

LEFT *A selection of commercial and hand carved rubber stamps*
BELOW *Some patterns printed with rubber stamps*

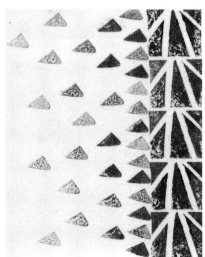

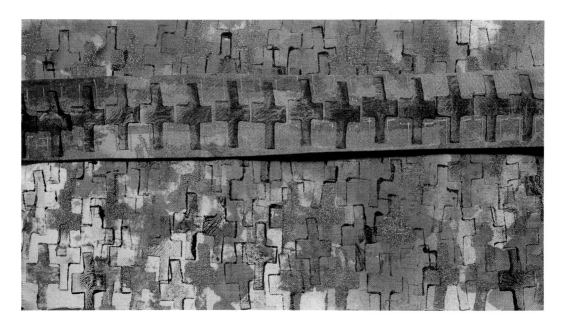

Printed with a rubber stamp carved into a cross

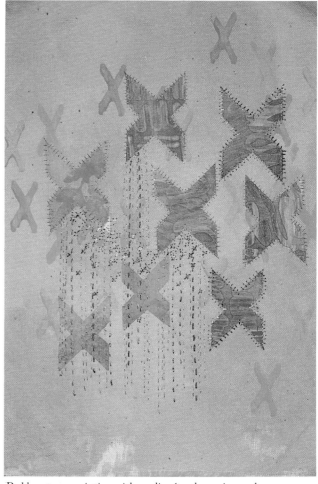

Suggestion for a smocked blouse using fabric printed with the same rubber stamp.

Rubber stamp printing with appliqué and running and cross stitches

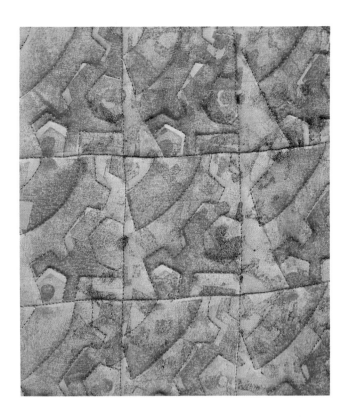

RIGHT *Sample of quilting using rubber stamp printed fabric (Alison Elliott)*
BELOW *Woven ribbons printed with rubber stamps (Diana King)*

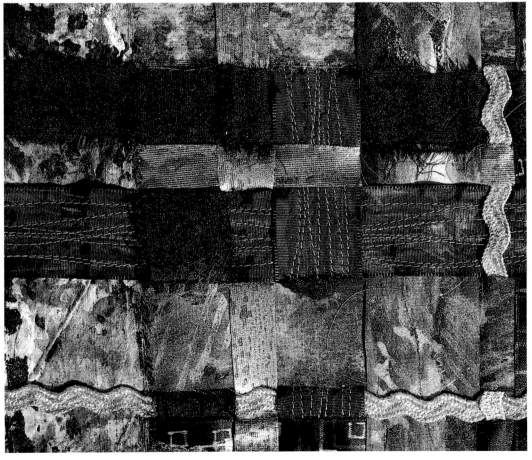

\mathscr{R}OLLING

Colour and pattern can often be transferred to a fabric more easily when using a roller than when block printing, and roller printing has now largely supplanted plate printing in industry.

Commercial rollers are made of rubber, lino, hard plastic, wood or foam sponge. Rollers can also be made using corks or short lengths of dowel with a nail stuck in each end to serve as handles. Small rollers are the most versatile and the easiest to use.

Rollers can be cut or incised with a craft knife or a saw to make patterns, or holes can be drilled into them. Thick dowel can be cut in half lengthways to make a half-cylinder roller, with a handle stuck on each half.

The type of paint used depends on the roller. Thin silk paints will run off a hard roller, but work well with sponge rollers. Thicker paints will stay on the hard rollers, although some will repel these water-based paints slightly, giving a more interesting print. Bleach can also be applied to a dischargeable fabric using a roller, and for this it is better to use a thick bleach. (See p. 114 for how to use bleach.)

Paint can be applied to rollers in two ways. One is to dab or brush the paint on with a brush, not necessarily aiming for smoothness, as the interrupted effect is interesting. Another way is to put paint on a sheet of glass or flat dish, roll it smooth, and then roll the colour on to fabric. This gives more even bands. With either method the amount of colour diminishes as you roll, giving a change of tone.

Paint can be rolled on to a fabric over a resist such as paper, ferns or scraps or coils of threads, making a secondary pattern.

Clean the roller under a running tap while the paint is still wet. If it seizes up from rust, apply some oil to the joints and run it back and forth until it runs smoothly.

Rollers can be rolled smoothly in bands, printed or dabbed to make isolated patterns, twisted while rolling, and generally used to make many different marks and patterns. These patterns can overlap, face different directions, or be combined with each other. The quantity of paint used makes a difference, as does the pressure and direction of movement. Different fabrics give different results, and the effect on velvet, as opposed to organdie or muslin, can be exploited in the final piece of work.

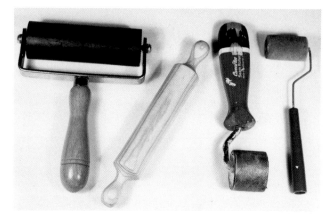

A selection of rollers

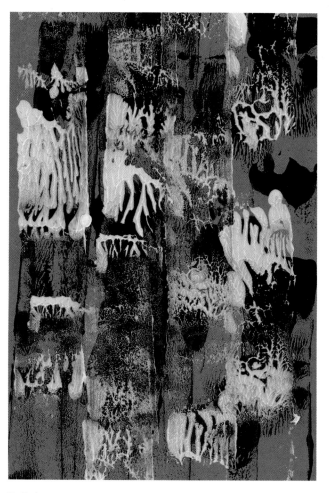

Rolled paint

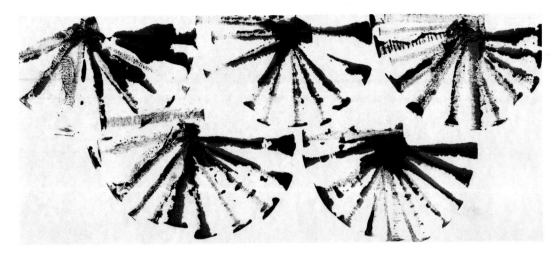

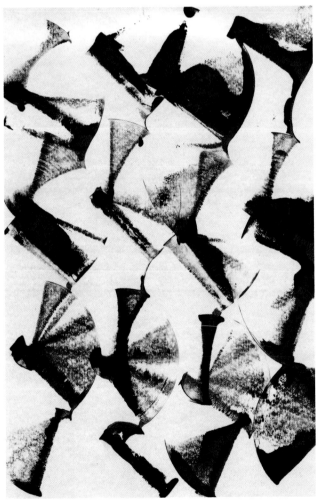

Patterns made by twisting and dabbing a paint covered roller

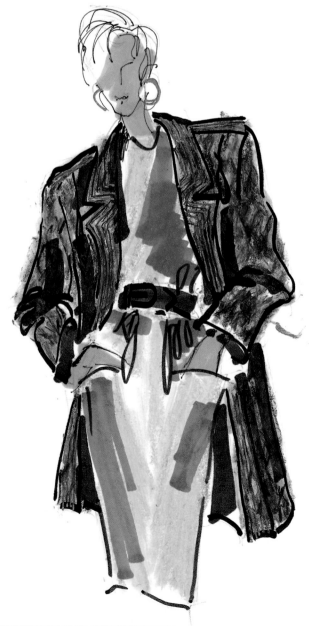

ABOVE *Samples of fabric decorated by rolling paint on them,*
ABOVE RIGHT *having been folded randomly between each rolling*
RIGHT *Suggestion for a jacket with added stitching in a fine gold thread*

ABOVE *Rolled paint fabric wrapped over strips of card as in the diagram. Long herringbone stitching adds glitter and emphasises the pattern*
RIGHT *Red, yellow, blue and gold fabric paint rolled on to muslin*

TRANSFERRING PHOTOCOPIES

Both coloured and black and white photocopies can be transferred to fabric, and fine silk and organdie give the best results. I have found that this method is fast to light (so far) and has been washed in a washing machine with no change in the print. Long-term results are not yet known, however. It is an excellent way of transferring a drawing or design to fabric, ready to be stitched. It is also the only really satisfactory way of getting a bubble print, with all its fine detail, on to fabric, as other methods just leave splodges. Your own photographs or designs, patterns, objects such as leaves, rubbings, or textures such as coarse fabrics, can all be used. You could photocopy an embroidery that you have done, transfer it to fabric, and then add stitching in a different colour, or on a different scale, or work it in a different technique altogether.

METHOD
Make a photocopy, either the same size as the original or an enlargement. Use quite a dark setting on a black and white photocopier, and quite dense colour on a colour photocopier. A fresh copy will work better than an old one, so make it just before it is to be used.

Half fill a jar with water. Then top it up to three-quarters full with white spirit. Add a small squirt of detergent and shake gently to mix. Paint the front and back of a photocopy with the mixture until it is really saturated (on photocopies from certain machines, you need only paint the solution on the back, as it smears the ink on the front: do a trial piece to check this). Leave to soak for at least five minutes.

Lay the fabric face up on a really hard surface such as a chopping board, lay the photocopy face down on top of it, and press with as hot an iron as the fabric will allow. Keep the iron moving slightly to avoid leaving marks, and hold the photocopy firmly so that it does not shift about. Peel back one corner to see whether the image has transferred properly. If it has not, keep on ironing for a few minutes longer.

How to make a bubble print, and the finished print on paper

TRANSFER CRAYONS

These crayons are applied to a smooth paper, such as computer paper, which is then laid on a synthetic fabric such as terylene, voile or poly-cotton, and ironed to transfer the colours. They must not be confused with fabric crayons (see p. 42) as they cannot be applied directly to the fabric, and are not fast on fabrics made of natural fibres. The colour range is limited and not very subtle, but this can be overcome to a certain extent by overlaying one colour on another.

After colouring the paper, lay it face down on the right side of the fabric, and iron to transfer the colour. Hold the paper firmly so that it does not shift, and peel back the corners from time to time to see if the colour has transferred. If it has not, keep on pressing. Each piece of paper will give two, sometimes three, prints, but the second print will not be as strong as the first one. The colour on the fabric after ironing is not the same as the colour on the paper, so do tests beforehand to see what the change is.

There are a number of ways of applying the crayons to paper, such as rubbing, drawing, making marks such as streaks or twists using either the pointed or blunt end, or making patterns using bands or curves of overlapping colour with the side of the crayon. These crayon marks can be loosened, or colours merged, with white spirit or turpentine applied with a brush or sponge. This wet method can be mixed with dry crayon marks, giving a change of texture.

Making indented drawings using these crayons is a good way of transferring a design to the fabric together with the colour. Photocopy a design and place it face up on a pad of newspapers. Using a ballpoint pen or knitting needle, draw the pattern, following the lines on the photocopy, pressing really hard to indent the lines on the paper. Then gently rub the crayons over the surface, rubbing across the indented lines and not along them, otherwise they will fill with colour. This leaves the lines voided. Iron the design on to the fabric as usual.

Another way of using these crayons is to cover a piece of paper totally with many layers of different colours, giving a very subtle effect. This can be scratched into with the point of a knife to create pattern or texture. Cut the paper into squares, stripes, or pictorial shapes, and glue them to a piece of greaseproof paper making a design. Then iron the design on to the fabric as usual.

Rubbings of the tread patterns on car tyres

A bubble print transferred to organdie from a photocopy

LEFT *A drawing of stones (Sue Kerry)*
BELOW *A photocopy of the drawing was transferred to silk and painted with silk paints (Sue Kerry)*

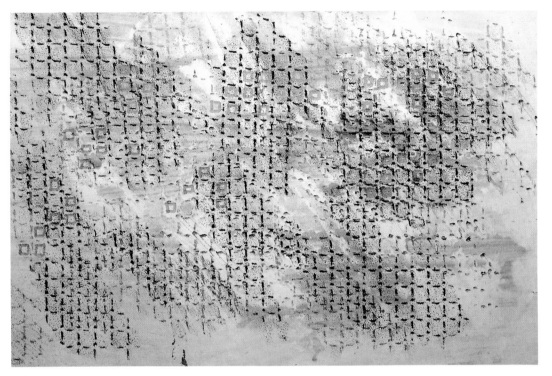

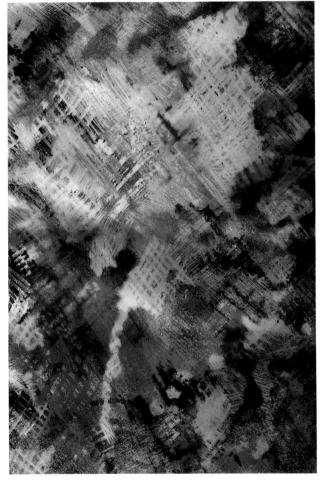

ABOVE *First a wax rubbing was made on paper using a pale blue transfer crayon with a thick plastic mesh under the fabric. Next blue and pink areas were coloured with transfer crayon. Then another rubbing was made using black transfer crayon. This was ironed onto the fabric and some details added with a gold pen.*

LEFT *A pattern on paper using the same crayons, scratched through with a scraperboard tool to give texture (Corliss Miller)*

TRANSFER PAINTS

These paints are made from disperse dyes, and were developed to colour synthetic fabrics which are otherwise difficult to dye. They are painted on to a non-absorbent paper such as photocopying paper, left to dry, and then ironed on the fabric. There are different brands available, some of which change colour considerably after ironing. Pebeo Transfer paints change colour the least, with Deka Iron-On the next best, but it is worth doing tests to see how the straight colours as well as the mixes will change. The colours can be diluted with water to make them paler, and are intermixable. One great advantage of these paints is that quite a few prints, sometimes as many as six or seven, can be made from each paint paper.

Although these paints are designed to be used with synthetic fabrics, mixtures of synthetics and natural fibres, such as polycotton, will work, but the result will be paler. A substance known as Cotton Finish, by Pebeo, has been produced to enable these paints to be used on cotton fabrics and still be fast – this means that cotton felt, velvet, knitted cotton, or muslin can be used, which was impossible previously. The liquid is painted on the fabric and allowed to dry before the paints are ironed on. A good use for Cotton Finish is to cover part of the fabric only with it, either randomly or in a pattern. Then iron the painted paper on to the cotton as usual. The result will be bright where the Finish has been painted on to the fabric, and much paler where it has not. Cotton Finish does not stiffen the fabric, and can be removed with water. After washing a fabric on which Cotton Finish has been used, iron it on the back.

There are many ways of applying the paints to paper, such as printing, spraying, spattering, dabbing, dripping, or rolling. They can be applied with a brush, sponge, cotton bud, fingers, or feathers. One layer or pattern can be applied, allowed to dry, and another layer or pattern applied on top. Potato prints can be done on a paper previously coloured by spraying or rolling. A piece of newspaper can be crumpled, dipped into the paint and printed on a paper already coloured by spraying. Then flat brush patterns can be printed on top when it is dry.

Transfer paints can be applied to a photocopy. This can be a photocopy of your own design, or of one of your photographs. Use a water-colour brush to fill in the areas in the design, allowing each area to dry before colouring the next one or the colours might mix together.

It is also worth covering some sheets of paper with transfer paints, either in smooth plain colours, or flooded with different colours giving a space-dyed effect. These papers can be ironed on the fabric before adding another pattern, giving layers of colours, or they can be used to colour fabrics in toning colours used together with more strongly patterned papers in patchwork of appliqué, for example.

The paper can be dry, wetted or completely soaked before applying the paint. It can be wet in some areas but not others. If you have made a mistake while painting the

A pattern built up using shapes taken from Kilims. This was photocopied ready to be painted

paper, stick another piece of paper over that area, and re-paint.

PRINTING

When the painted paper has dried, it is placed face down on the right side of the fabric. Set the iron to the correct temperature for the fabric, and iron on the back of the paper to transfer the colour, moving it about slowly to avoid leaving marks. This can take some time, so be patient. Hold the paper firmly so that it does not shift, and peel back the corners from time to time to see the result. If you want a pale print, less ironing will be needed than for a dark one, and more prints from the same sheet will be possible. It is possible to print through a sheer fabric on to an opaque one so that both fabrics will be printed.

Printing can be done through another fabric such as net or lace, to give a voided pattern. A similar effect is achieved by laying lengths of threads or scraps of fabric between the paper and fabric. Flat leaves can be placed between paper and fabric before ironing, and will leave a silhouette. They will have picked up some of the colour, so use them to print on another piece of fabric. Cut or torn pieces of paper, or doileys, can be also be used.

Try cutting one of the papers into strips. Print the strips either all in one direction or all at different directions. Then cut them into squares and print them on top. The strips could be woven and the weaving printed.

Try folding or crumpling the paper before printing it.

Cut a painted paper into 2cm (3/$_4$in) squares. Draw a grid of 2.5cm × 2.5cm (1in × 1in) squares on greaseproof paper, and glue the painted square into the drawn ones. It can be in one of the corners, in the centre, or randomly placed. When the glue has dried, print the design.

Apply stripes, squares, or cut or torn shapes of one fabric on another, and print on it. This is most effective if the fabrics are different, such as shiny applied to matt.

Print on a pleated fabric. This could be commercially pleated, in which case it stays like that. If, however, the pleats have been held taut by pinning through each end into a soft board, the pins can be removed, the fabric repleated, and another print made on top.

Print over stitching, either hand or machine. This can be a way of colouring the stitching and the fabric at the same time, or the stitching can be removed to leave un-coloured marks on the fabric.

Consider the finished result. It might be a good idea to add something else on top, such as block printing with metallic or general-purpose paints, or a light flicking or spattering with gold or a stronger colour.

Peacock feathers were laid on a fabric and transfer painted paper laid over them and ironed to transfer colour to the background

Suggestion for a fan using transfer printed fabrics

A photocopy painted with transfer paints

First a rubbing was made with a candle on paper over a thick mesh, then transfer paints were flooded on to the wetted paper. After the paper had dried, it was ironed on to fabric

A panel based on an eastern dress, with applied fabrics decorated with transfer paints (Yvonne Morton)

PAINTING ON FABRIC

Provided the paint is not too thin, it is quite possible to paint on most fabrics, even on some silks, without using any other substance as a resist to keep the paint within boundaries. The best way to do this is to stretch the fabric on a frame, or tape it to a board over a piece of blotting paper or another fabric, such as calico, which will absorb any excess paint. Use a fairly dry brush and paint just thick enough not to spread on the fabric. If the fabric has already been coloured, the paint will be even less inclined to spread.

If this does not work on your fabric, silk paint manufacturers provide substances that can be painted on the fabric and allowed to dry, to prevent the paint running over it. Fine detailed work is then possible over the top.

It is interesting to plan wet and dry painted areas in one piece. First wet parts of the fabric, apply the paint, and allow it to dry. Then continue painting on the dry fabric. Fabric pens can also be used to add details and fine lines.

BRUSH MARKS

Experiment with your brushes to see how many different marks you can make on the fabric. Pull it, push it, twist or roll it, dab or print with it. All these marks can build up texture and pattern on the fabric which can be emphasized with small pieces of applied fabric and stitching later. Each mark will look different on different fabrics, so try all the fabrics so that you can see which is the most successful. Remember that the marks on fabric will not be exactly the same as on the paper design, especially if you are painting on velvet or a material with a visible weave; this can, however, be an advantage.

PAINTING WITH EMULSION

Fabric can be painted with household emulsion. Thin the emulsion with water to a thin cream and try painting it on to a spare piece of fabric to see if it is the right consistency. White emulsion can be coloured by adding acrylic paints, fabric paints or pigment powders. Stretch the fabric on a flat surface, or a frame, and apply the paint with a brush, roller, or sponge, using any of the methods or patterns given in this book. Emulsion gives body to a thin or transparent fabric, is flexible enough to stitch through after it is dry, and can be hand or machine washed. Painting, printing, rolling, marbling, stencilling or screen printing can be done on the painted fabric. A white emulsion base makes colours applied to the surface much brighter.

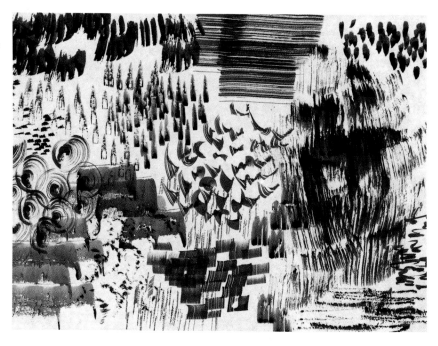

Some of the brush marks that can be made by dabbing, rolling and twisting the brush.

GESSO

This mixture of whiting, rabbit's skin glue and other substances has been used for centuries for priming canvas for oil painters. Modern acrylic gesso contains acrylic polymer, latex emulsion and white pigment. The advantage of this type is its increased flexibility, and when used on fabric, it can be stitched through with ease.

Gesso (pronounced *jesso*) adds body to fine fabric and stops the edges fraying. Fabric paints reactly slightly differently on it, and very detailed painting can be done on a fabric covered with a thin layer. Only parts of the fabric need to be covered, which exploits this difference.

Although gesso is white when bought, if wished colour can be added, in the form of pigments or fabric paints. The gesso can be thinned with water and applied with a brush, roller or palette knife. It can be printed on using the edge of a piece of card, which leaves raised lines on the fabric.

Brushes and tools can be cleaned with water, but this must be done before the gesso has dried.

SPONGES

Sponges can be used to paint on fabrics and can be dabbed, streaked or printed on the surface, leaving marks which can build up into groups of flowers and leaves, landscapes or gardens. The side or a point of the sponge can be used, or it can be cut to give particular marks. Try using different types and shapes of sponge, different types of fabric paint, and different pressures on the sponge. When aiming for a sense of depth, in a landscape, for example, start with the area that is the furthest away, using softer, greyer colours. Gradually build up the painting with stronger colours and firmer marks in the foreground. When the paint is dry, fix as usual, and the painting is then ready to have scraps of fabric applied to it and, finally, the stitchery to emphasize some of the patterns or textural areas.

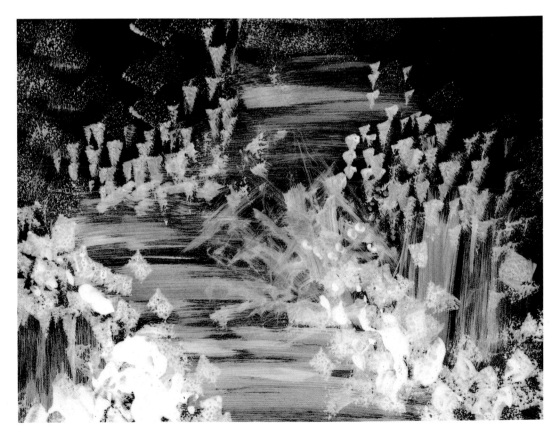

A sponge painting showing some of the marks sponges can make

ABOVE *Painting on gesso-covered fabric based on an ancient Egyptian pattern using fabric paint and gold paint made with metallic powder (Judith Butt)*

RIGHT *A painting of part of a rock using a one-stroke brush and a water-colour brush. Small dark marks were made by rolling a brush along the surface*

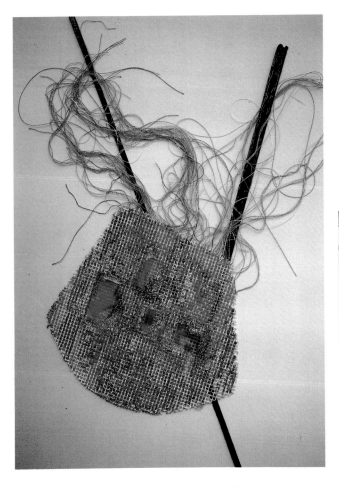

Fairweather Kite. *Painting on canvas, applied fabrics and machining (Yvonne Morton)*

Machine and hand stitching on painted fabric (Corliss Miller)

\mathcal{S}TARCH RESISTS

These resists have a long history of use, particularly in Africa. They are cheap, quick and easy to use. Although they do not adhere as well as wax or gutta, they are perfect to use with fabric paints. They are not suitable for use with liquid dyes, when they tend to turn into a soggy mess.

Starch resists can be made with wheat flour, soya flour, rice flour, ground rice and laundry starch. The paste can be applied with a spoon and then spread with a knife, or a fork can be drawn through it to make patterns. The paste can be flicked or spattered, squeezed through an icing syringe or a plastic bottle, printed with a block, or dabbed through a stencil. Starch pastes can be spread on a fabric and left to dry, which produces a good crackle effect that is slightly different on each one. The fabric can be framed (in which case the paste cracks as it dries) or left unframed (in which case the fabric will crumple as the paste dries, and cracks are produced when the fabric is pulled out to straighten it).

When the paste has dried, paint is sponged or dabbed on with a soft brush. Thin silk paints are often the best to use for this method, as they seep down to the fabric between the cracks in the paste. If using a thicker paint, it will need to be diluted. Paint can be mixed with the paste so that it will gradually be transferred to the fabric as the paste dries, and a second colour can be brushed over the top.

When the fabric has dried, crumble off the main bulk of the paste, and scrape the rest off using a palette knife. Iron the fabric to set the paint, or set the colour with a hair-dryer, and then rinse it, if necessary, to get off the final remains of the paste.

RECIPES

1. Flour paste (wheat or rice flour)
Mix flour to a paste with cold water. Add more cold water to give the consistency of salad cream. This can be used raw, or cooked, which gives a slightly different effect.

2. Soya flour
Mix to a smooth paste with cold water. Add more cold water to thin it down. This resist is not very adhesive and crumbles off easily, but is easy to use combined with spraying. To make it more adhesive, mix it with egg white, then add water to thin down.

3. Wheat or laundry starch paste
15gm ($^1/_2$oz) dry powder is mixed with a small amount of cold water taken from 80ml ($2^1/_2$fl oz) to make a smooth paste. Add the rest of the water. Add 5ml (1 teaspoon) olive oil. Boil the paste, stirring all the time until it becomes smoother and thinner. Stir frequently as it cools. This paste is ideal for block printing.

4. Mixed paste
1 tablespoon flour, 1 tablespoon rice flour and $^1/_2$ tablespoon laundry starch are mixed with a little cold water to make a smooth paste. Add $^1/_2$ litre (15fl oz) cold water and heat in a double boiler for about 10 minutes. Apply the paste hot.

Flour resist on velvet, showing the cracking that occurs as the mixture dries

Cushion is starch-resist fabric, using squares of fabric with frayed edges

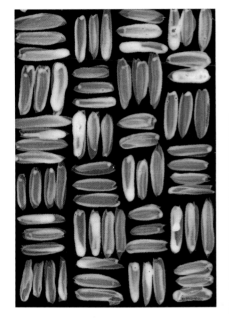

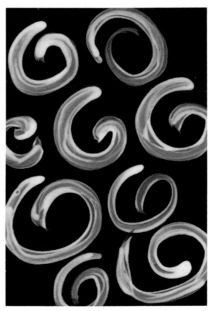

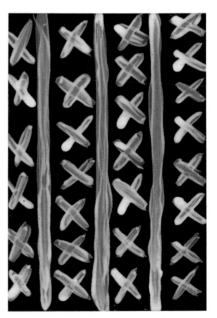

Some of the patterns that are suitable for drawing on the fabric using starch pastes

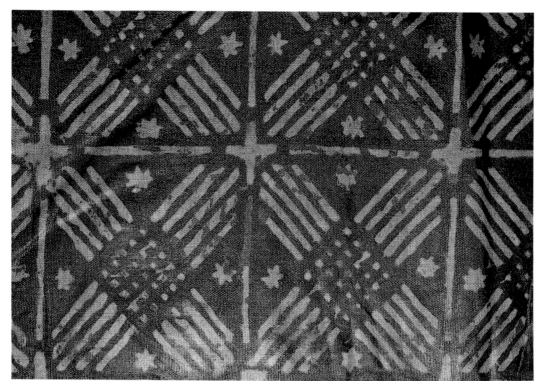

LEFT *A fabric from Nigeria decorated with a starch resist pattern*

BELOW *Two shades of blue were applied to silk over starch resist, showing the fine detail that can appear*

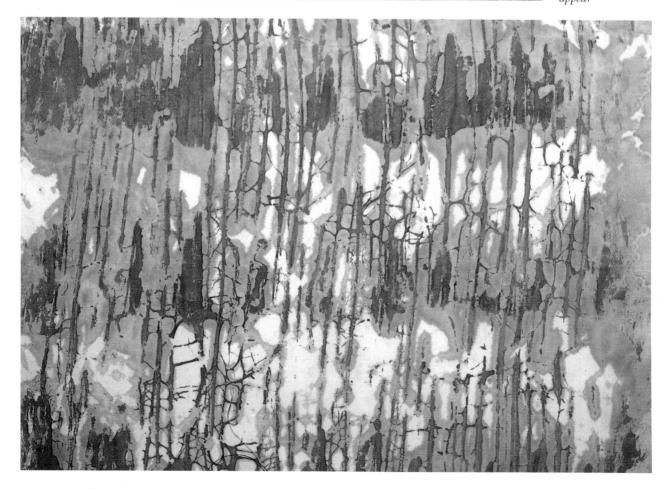

RIGHT *Appliqué border using fabric decorated with paste resist and gold spray, and cut felt shapes stitched on top (Indu Malhotra)*

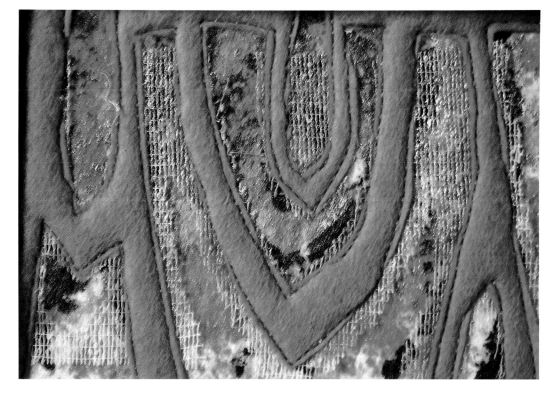

BELOW *Machine stitching outlining shapes based on a drawing of crystals on a fabric decorated with splattered flour paste and painted (Sue Kerry)*

*U*SING GUTTA AS A RESIST

Gutta is a liquid latex with the consistency of syrup. It is applied to fabric, usually fine silk, to create a barrier which keeps the paint within defined areas. It is usually applied with a pipette or from a tube in fine lines following a design previously drawn on the fabric. When the gutta is dry, silk paint is applied to the enclosed areas. The most common types of silk paints are those that are heat fixed. Those that need to be steamed to fix them give brighter colours, and instructions on the steaming process are included with the paints when they are bought. There are two types of gutta: one is water-soluble, and the other is spirit-based. If the gutta is too thick, it will sit on the surface of the fabric and not penetrate it to create the barrier; if too thin, it will spread and not be waterproof. Keep the top on the bottle when not in use, as contact with the air will cause the gutta to thicken. Water-based gutta can be diluted with a little water, and spirit-based gutta with a dilutant sold by the manufacturers for that purpose. Most gutta is a clear liquid, which is removed after the painting, leaving a white outline. However, coloured and metallic guttas are now available which are designed to stay in place, and will withstand gentle washing (but not dry cleaning).

TEXTURES USING GUTTA

Another way of using gutta as a resist is to apply it as areas of texture rather than in lines. It can be applied with a sponge, streaked or dabbed with a brush, printed using a stick or other object, or even screen printed on to the fabric (see p. 51). When screening it, ensure that the fabric on the screen is extremely fine, and that the gutta is scraped across the screen with a hard squeegee, to leave only a thin layer. It helps if the silk has a layer of calico under it to absorb any surplus. If printing or painting the gutta on to the fabric, the results are more satisfactory if the silk is stretched on a frame. Allow the gutta to dry completely before applying any paint, which takes some time.

Having applied the gutta in this manner, there is no point in carefully painting on the colours as there are no conventional boundaries, so it is better to apply the paint with a sponge or large brush in a random fashion. Do not get the silk too wet when using a water-based gutta, as it will dissolve too soon and not resist the colour.

Allow the paint to dry and fix it with a hair-dryer. Then wash the gutta out under a cold water tap, dry and then iron.

Some of the marks possible by applying gutta with the end of a dowel rod, a one-stroke brush, and a sponge

DRAWING WITH GUTTA

It is usual to use a pipette for this, which can be supplied by the retailer. It has a long nozzle which is pierced with a pin to allow the gutta to be squeezed out. A better system is to cap it with a metal nib which is held to the nozzle with sticky tape and enables finer lines to be drawn. The nibs come in three different sizes: the lower the number, the finer the hole. They should be kept ready for use in a small airtight container covered with white spirit, if using spirit-based gutta, or water, if using the water-based variety.

Fine silk fabric is stretched on a frame, and the design is pinned to the back of it and the lines traced using a hard pencil. Hold the pipette like a pen and squeeze gently, forcing the gutta along the lines of the design into the silk, which it should penetrate. Try to achieve an even flow and a continuous line, as the paint will flood through any gaps. Turn the frame over to check that the gutta line shows as transparent and apply another line to the back if it does not. Allow the gutta to dry completely.

Apply silk paints with a pointed water-colour brush. Touch the brush to the centre of an enclosed area and allow the colour to spread to the gutta barrier. Do not apply too much paint, or it will flood across the gutta into the next space. If the paint has not filled the area, then add a tiny bit more, but be gentle. When painting large areas of colour in the background, a sponge brush can be used to cover the ground more quickly. Dry, fix the colour and remove the gutta as before.

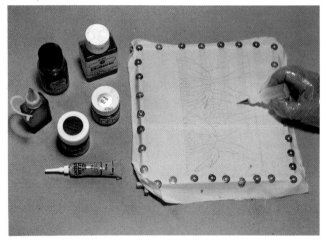

Applying gutta using a pipette with nib to silk stretched on a frame

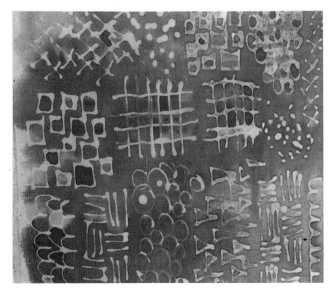

Patterns drawn with the pipette

Drawing of a bird on a Javanese batik which could be drawn with gutta and painted

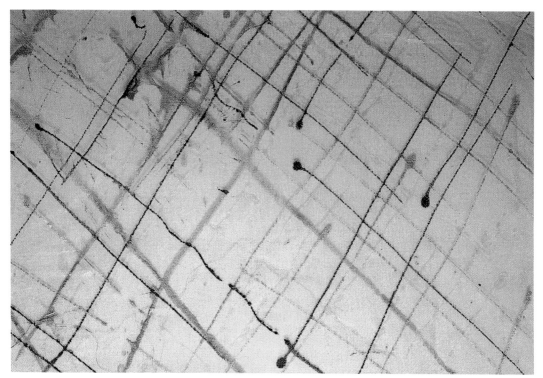

LEFT *Fabric decorated with lines drawn with coloured gutta in a pipette (Julie Smith)*

BELOW *Some patterns and textures possible when applying gutta with a pipette, a sponge, a screw head, a fork and a dowel rod*

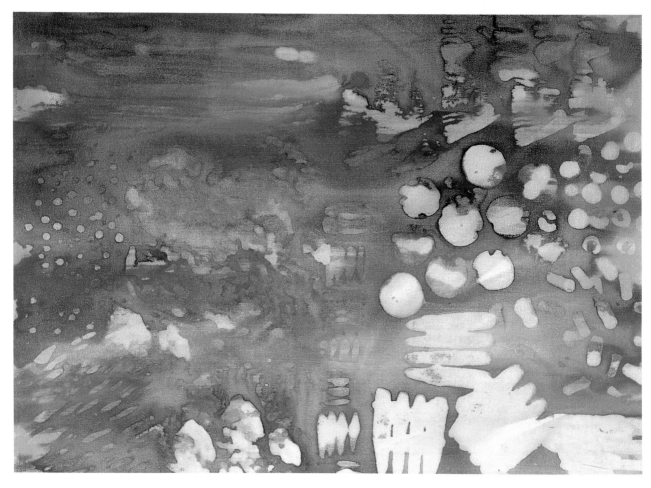

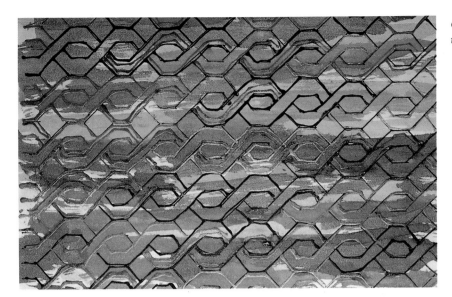

Gold, silver and black gutta applied to silk, with silk paint freely brushed over the top

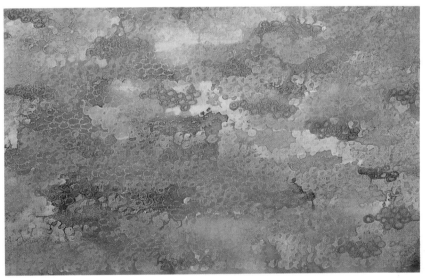

Multiple circles drawn using red, gold and clear gutta, painted in random areas of colour

The same fabric quilted to make a bag decorated with bands of lace machined on water-soluble fabric

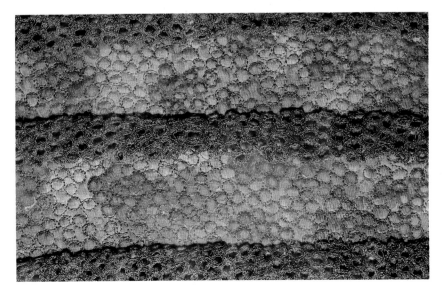

\mathcal{U}SING CANDLES

Ordinary household candles can make a wide variety of marks and effects which will resist fabric paints on papers and fabric. They can be used in various ways, either cold or melted, and the wax is ironed off after the paint has dried.

RUBBINGS

If the fabric is placed on a textured surface and a candle rubbed on to it, wax is deposited on the fabric although what is happening cannot be seen. Small pieces of fabric can be held over the texture; but for larger pieces it is better to pin the fabric to a wooden frame to hold it flat, then place the frame fabric side down on the texture, and hold it with one hand while rubbing with the other. Press quite hard with the candle, but not so hard that the fabric is dragged and moved out of place.

Try mesh fabrics such as canvas, wire mesh, leaves, textured glass, baskets and chair seats, stencils and templates, coloured pencils lying flat in their tin box, and textures such as eggshells or rice glued to paper.

When the rubbing is finished, gently dab or sponge the paint on the fabric, making sure that it is not so liquid that it flows underneath the wax resist. Dry. Lay the fabric face down on newspaper and iron it from the back, melting the wax so that it sinks into the paper. Repeat on clean sheets of paper until no more wax comes off. Continue ironing for the rest of the five minutes necessary to set the paint. Then place the fabric in a bowl, add some soap flakes and pour boiling water on it, stirring the fabric around all the time. Rinse and dry.

MELTED CANDLES

A candle can be lit, and then used to draw streaks on the paper or fabric as the wax melts. If the fabric is in danger of being burnt, blow the candle out while drawing, relighting it at another candle to melt more wax.

Wax dropped on the fabric from a lighted candle will always make circles, and these can be built up into all sorts of patterns such as grids, bands or dense areas of drops thinning out to leave more fabric showing.

APPLYING THE PAINT

The paint can be applied with a sponge or brush, or it can be sprayed or rolled on to the fabric. Once it is dry, more wax can be applied and another coloured paint added. Alternatively, more than one colour can be applied after the first waxing, giving a multi-coloured or space-dyed effect. Allow the paint to dry, and remove the wax as before.

 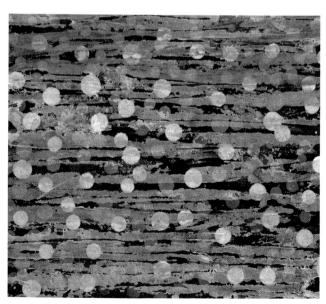

Melted candle wax streaked and blobbed, acting as a resist to streaked paint

LEFT *Suggestion for a pillowcase and sheet border decorated with dropped candle wax resist and eyelets*
BELOW *Candle wax was dropped onto a piece of paper, which was then painted with transfer paints. While it was still wet, a print was taken of this on to a clean sheet of paper. Both can now be printed on fabric*

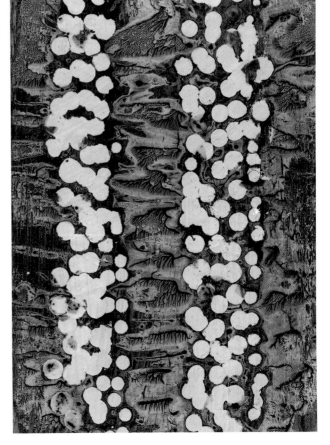

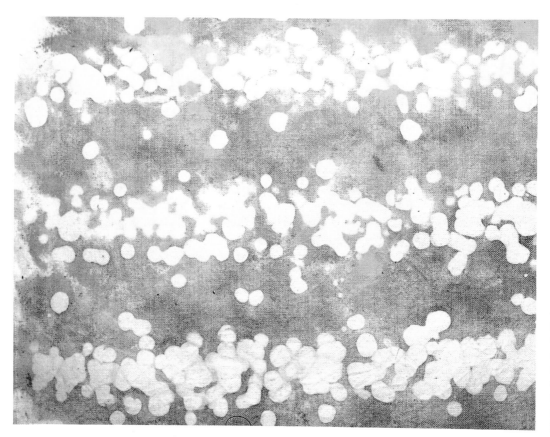

Melted candle wax dropped and streaked onto silk and gold lurex, and the painted, the example on the left was rewaxed and more colours added in layers

A noticeboard with papers and fabrics decorated using dropped candle wax resisting the applied paint (Linda Rakshit)

WAX RESIST

Using melted wax on fabrics to resist the application of dye has a long history, especially in the East. It is known as Batik in Java, where it is practised extensively, but is also much used in India and other countries. It is a lovely medium to use, as it can be applied to the fabric in many different ways, hardens quickly so that there is no waiting before applying the paint, and smells lovely while you are working with it. If you have not worked with melted wax before, start by melting some kitchen candles in a saucepan over a very low heat. The temperature of the wax should be about 120°C (235°F). If it is too cold it will sit on the surface of the fabric and not resist the paint. Spread a small piece of fabric over a piece of silicon paper, and brush or dab the wax on to it, making patterns. It will harden quite quickly, and you can then brush fabric paint on to the fabric. Allow to dry. Remove the wax as explained below.

If you decide you like working with wax, you may find it much better to buy a proper wax pot, which is thermostatically controlled and easier to use.

WAXES
Paraffin wax is the cheapest to use, but is rather hard. It is good for crackled effects. If beeswax is added to the paraffin, it gives a better all-purpose mixture which can be used in a canting (tjanting) as well as on a brush. Aim for a mixture that is one part beeswax to three parts paraffin wax. Batik wax is a microcrystalline wax sold in granules and is also very good. Pure beeswax is rather soft and pliable, but good for drawing fine details with.

FABRIC
Fine fabrics, such as silk or cotton, are the best to use for waxing, as the wax will penetrate the fabric easily and resist the paint. The fabric is easier to use if it is stretched on a frame, or laid on paper – silicon paper is best, as wax does not go through the fabric and stick to it.

TOOLS
Wax can be applied with a brush, but it is best to keep old ones especially for this purpose as it is impossible to remove it completely from the brush. Brushes can be cut into to give different marks on the cloth.

A canting (tjanting) is a tool with a bowl to hold melted wax, and a spout for it to emerge through. The handle is made of wood so that it is comfortable to hold. They can be bought with spouts of various sizes giving thin or thick lines, and some have two or three spouts.

Wax can be printed using metal tools such as large screw heads or bent pieces of wire.

CLEANING WAX OFF
First lay the fabric upside down on a pile of newspapers and iron it from the back to melt as much of the wax as possible. Keep changing the paper as the wax melts in it. The paints will be fixed while you are doing this. Then put the fabric in a bowl with a few pure soap flakes. Pour boiling water over it, stirring hard with a wooden stick as you do so to prevent the melted wax from re-settling on the fabric. Remove the fabric, rinse it and hang it up to dry. You might need to repeat this process if the fabric is stiff when it has dried. Dry cleaning will also remove any wax which remains after ironing. Allow the water to cool and pour it away at the bottom of the garden, not down the sink, or strain it, keeping the wax to throw away with the garbage, and then pour the water down an outside drain.

CRACKING
When the wax has hardened it can be cracked before painting, giving a network of fine lines. To do this, com-

Crackling that results from hardened wax being crumpled before the painting

pletely cover a piece of fabric with melted wax (preferably paraffin wax) using a brush. Leave to harden for a short time in your fridge or freezer, and then crumple the waxed fabric in your hands. Place it on a piece of paper and brush thin fabric paint over it. You might need to work the paint int the cracks somewhat, but keep picking the fabric up and looking at the back to see what is happening.

BRUSHING WAX

Differently shaped brushes dipped into hot wax and then applied to the fabric will leave lovely sweeps, marks or patterns. Flat and fan-shaped brushes can be printed, household brushes can be cut into to give a spaced tooth effect, or you can make your own 'brushes' by binding short lengths of string or twigs to a piece of dowel. Sponge brushes can also be used to apply wax, as can toothbrushes, nail brushes or washing-up brushes. They will all leave different marks.

Dip the brush into the wax, scrape off some of it, and apply it to fabric which has been stretched on a frame. Allow to harden, and apply the paint. After the wax has been removed and the paint fixed, another layer of wax can be brushed on in different places, and a different colour paint applied. Start with a pale colour and build up to the darker ones, and remember, if the paint is transparent, the underneath colours will show through and alter the later layers.

If you wish to colour a very large piece of fabric, and do not have a big enough frame, take it outside and lay it on the grass. The wax pot can also be taken outside if connected to an extension lead, and it then does not matter how much mess is made. Weigh the fabric down with stones at the corners, and roll up excess yardage if you cannot reach into the middle. Use a large brush and apply the wax with free, sweeping movements, Details can be added inside later if wished.

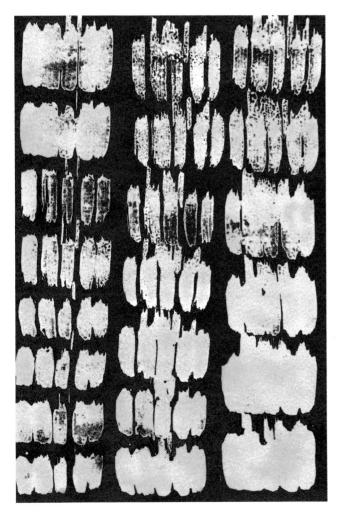
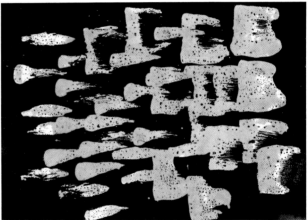
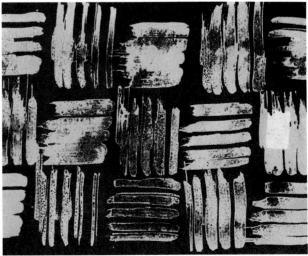

Samples of the marks made by dabbing and brushing wax on to fabric, and then painted with fabric paints

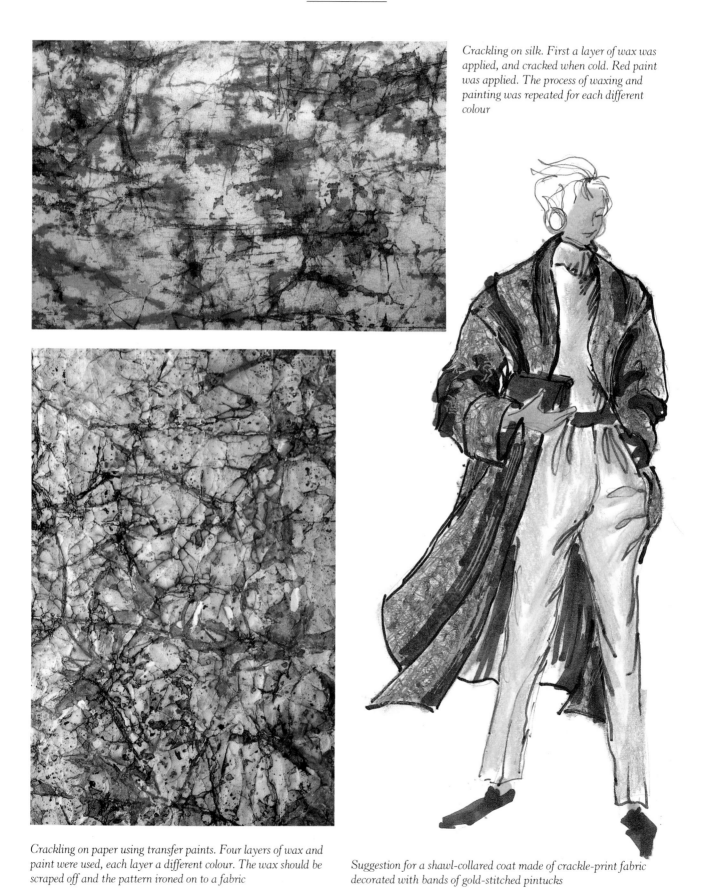

Crackling on silk. First a layer of wax was applied, and cracked when cold. Red paint was applied. The process of waxing and painting was repeated for each different colour

Crackling on paper using transfer paints. Four layers of wax and paint were used, each layer a different colour. The wax should be scraped off and the pattern ironed on to a fabric

Suggestion for a shawl-collared coat made of crackle-print fabric decorated with bands of gold-stitched pintucks

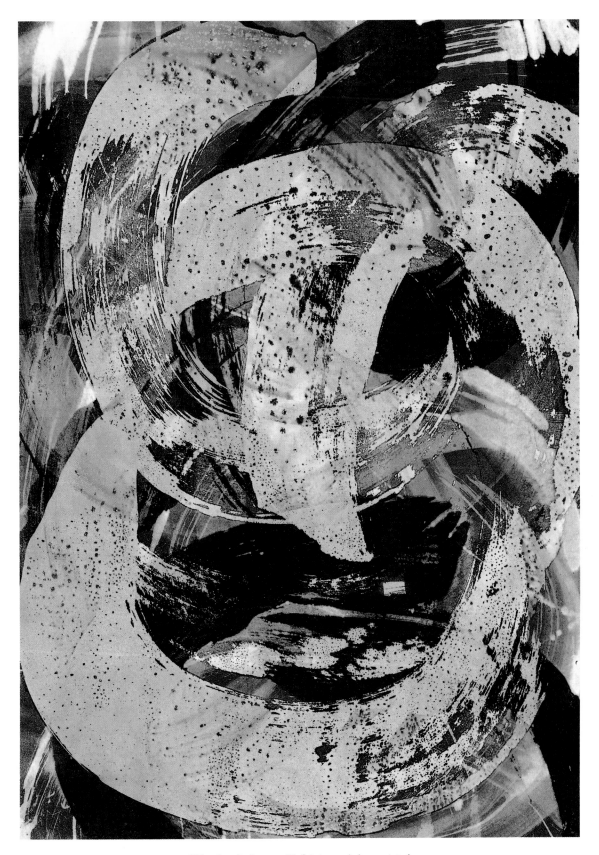

Wax brushed on to silk fabrics and then painted

PRINTING WITH WAX

In Indonesia special blocks made of copper wire and nails are dipped into molten wax and then pressed on to fabric. After the wax has hardened the fabric is dyed. If only small areas are to be printed, the edges of a piece of card can be dipped into the wax and used.

Blocks can be made by sticking small pieces of aluminium strip to a piece of wood, driving nails into a cork, using metal implements such as forks, or by bending wire into a shape and leaving a long tail to hold it with. Leave the block in the hot wax for a minute to warm up before printing with it. Lift it out of the wax, shake gently to remove any excess, and press it on to the fabric which has been laid on a piece of silicon paper or stretched on a frame.

Paint the fabric, dry, and remove the wax as before. Many layers of printing and painting can be built up, or a multi-coloured effect can be achieved by dabbing the fabric with different colours at the same time. If the paint is fairly wet, the colours will blend into each other; if the paint is on the dry side, then they will stay separate.

DRIBBLING AND FLICKING

Wax can be flicked or dropped on to the fabric using a brush, giving a negative version of the flicking patterns on page 38. Any type of wax can be used for this method. Frame the fabric so that it can be turned round and the flicking done in different directions. Paper stencils could be laid on the fabric beforehand to give silhouettes, but quite a lot of flicking needs to be done to show them up.

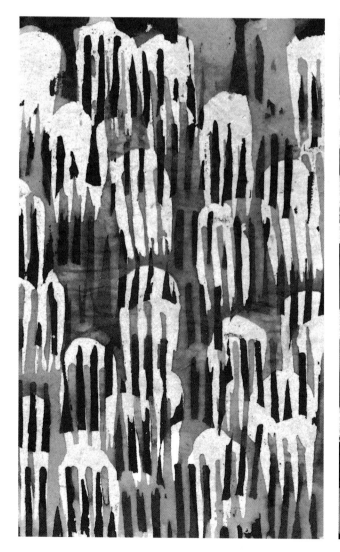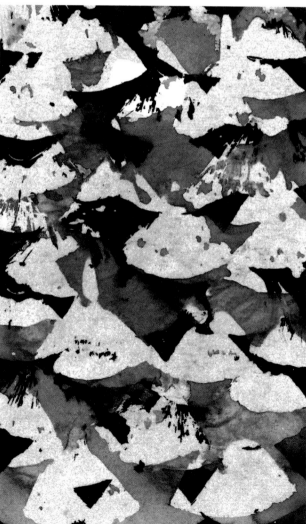

Forks and fan brushes used to print patterns on fabric to resist the paint. Layers of printing and painting give overlapped shapes in different colours

USING A CANTING (TJANTING)

This tool is easily available (see suppliers' list p. 143) and is used for drawing lines and dots in wax on a fabric. The canting (tjanting) is dipped into the hot wax and left for a minute to heat up. Lift it out, holding in your hand in the same way as you would hold a pen, but with the thumb uppermost. Keep a folded piece of soft kitchen paper underneath to prevent drips spoiling the design. Touch the spout on the fabric, and trail it across so that an even line is formed. Ensure that the wax is penetrating the fabric, and as soon as the canting cools down, put it back into the hot wax to warm up again. This drawing takes practice and it is worth practising short lines, circles, dots, wavy patterns and small shapes on a spare piece to build up the skill.

The best fabrics to use are thin or medium weight Habotai silks and cotton lawn. If the fabric is too thick, the wax will not penetrate it. Transfer a design to the fabric by laying it on top of a design drawn with a black pen, so that it can be seen through. Tape the fabric in place to stop it shifting, and trace the design with a hard pencil. Then frame the fabric and apply the wax. Turn the frame over, and if there are any lines that the wax has not come through, re-wax them on the back.

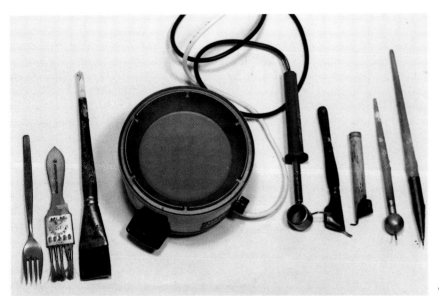

Waxing equipment; a wax pot, different canting (tjanting) shapes obtainable, fork and brushes

Some of the patterns that should be practised when first using a canting (tjanting)

Drawing of cell structure suitable for drawing in wax

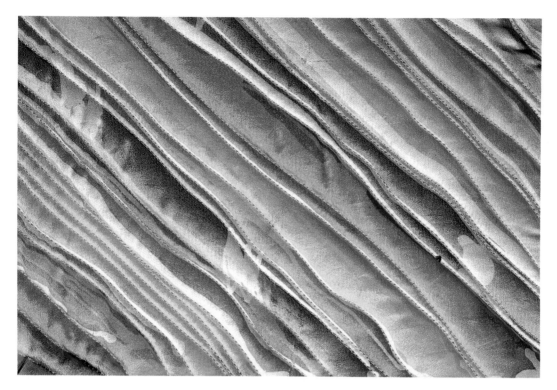

ABOVE *Quilted satin decorated with wavy lines drawn in wax, resisting the silk paint*
LEFT *Wax printed with forks, painted with Procion dyes and partially discharged.*

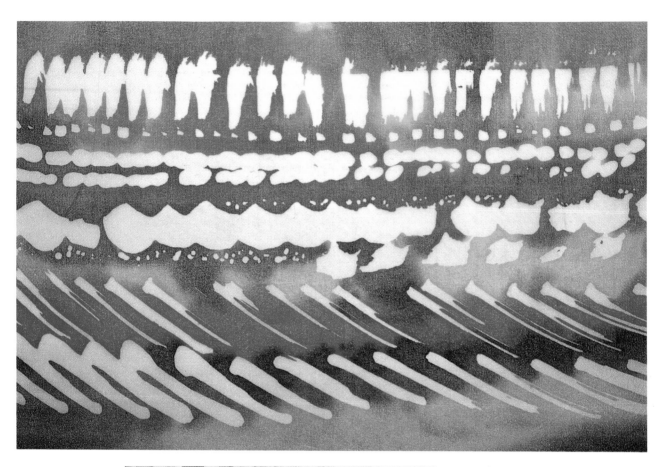

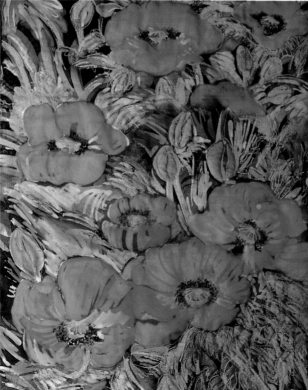

ABOVE *Some practise is necessary when first drawing with wax*
LEFT *Panel using wax resist and painting (Ros Arno)*

\mathscr{D}ISCHARGE DYEING

Discharging, or bleaching, is the process of removing colour from previously dyed fabric. It is used to give a light pattern on a dark fabric, and can be left as it is or re-dyed or over-printed in another colour. It has been used for centuries, particularly in Italy, to make the most wonderful patterned fabrics that cannot be produced in any other way.

Not all dyes will discharge. About 60 per cent of industrial dyes will, as will direct and fibre-reactive dyes (Procion MX). Vat, disperse dyes and fabric paints will not discharge. Some fabrics will discharge to cream, tan, rust or grey, and some to other pastel colours. It is possible to buy discharge fabrics in black and navy (see suppliers' list, p. 143) which are specially dyed for this process, otherwise you can try the fabrics that you have in stock, or dye your own.

BLEACH
Bleach will discharge many fabrics, and should be diluted to at least half strength with water before use. It can be applied with a roller, brush, sponge or spray, or it can be dabbed through a stencil or printed on to the fabric. It can

be thickened with Manutex, is it is otherwise too thin for printing. Allow to dry, and then neutralize the fabric by painting on a solution of one tablespoon of sodium metabisulphate dissolved in $1/2$ litre (1 pint) of cold water. Many people are concerned about using bleach on fabric, but if it is properly rinsed and neutralized, there should not be any problem.

FORMASOL
There is another discharging agent which can be obtained in small quantities under the trade name Dygon or Pre-Dye. Make up according to the instructions but using only a quarter as much water. Use while hot and apply as for bleach. This will often leave green or turquoise colours, which will turn to cream if the fabric is then steamed for 10 minutes.

INKS
Quink ink, both black and coloured, some other writing inks, and coloured drawing inks will all discharge with bleach. This is useful when designing, but ink is neither light nor washfast on fabric.

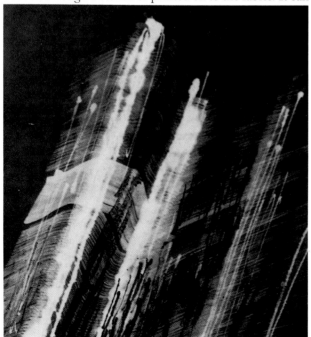
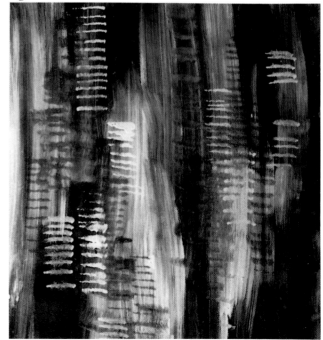

Patterns made by brushing and dabbing bleach on to dyed fabric

FELT-TIP PENS

Some felt pens will bleach: again this is useful for designing.

POTASSIUM PERMANGANATE

This dyes fabric brown and can be discharged with lemon juice. Dissolve 1 teaspoon of crystals in $^1/_2$ litre (1 pint) of hot water, and leave the fabric in the solution for 3 minutes, stirring as much as possible to avoid streaks. Rinse in cold water and pass through a caustic soda bath (sprinkle 50g ($1^3/_4$oz) caustic soda flakes in 4 litres (7 pints) cold water and stir until clear). When the colour change is complete, rinse the fabric in cold water. When dry, apply lemon juice to discharge the colour.

PROCION MX DYES

Each colour will discharge to a different colour which must be discovered by testing. Make up small quantities of dye by mixing $^1/_2$ teaspoon of dye powder with cold water to make a paste. Add 2 teaspoons salt, 2 teaspoons soda and about $^1/_4$ litre ($^1/_2$ pint) hot water. Stir until all is dissolved. Paint this on to fabric cottons, linens, silks or rayons only, not synthetics or wools) and dry. Iron to fix. Then experiment with bleach and formasol.

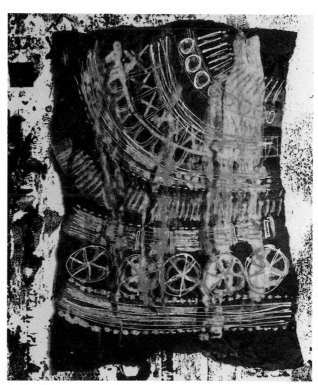

Patterns made by dabbing bleach on to dyed fabric using the edge of a piece of household sponge

A bleach drawing of a detail of an Egyptian mummy on tissue paper, glued to a piece of paper decorated with rolled Quink ink and bleach

LEFT *Design using coloured inks with bleach marks made using a brush and the end of a stick (Jan Hayes)*
BELOW *Procion dyes on silk bleached to give different colours*

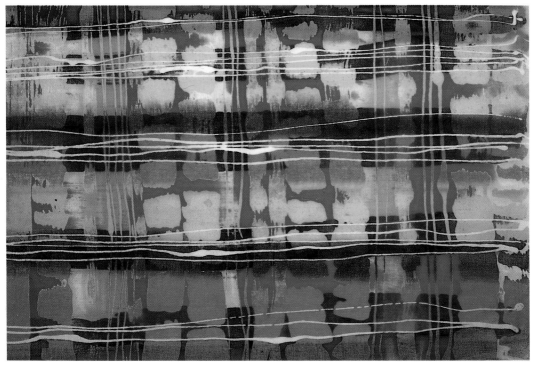

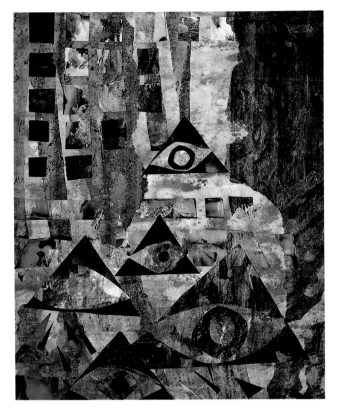

Design using inked papers and bleach, based on a painting by Klimt (Judith Smalley)

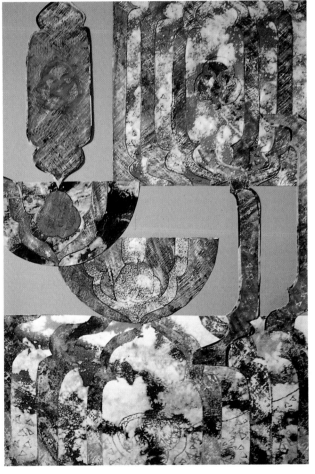

Design for a chasuble using inked and bleached papers, with added wax crayon, scraped with a knife to give texture. This will be carried out using wax resist? Procion dyes and bleach, with fabric crayons (Corliss Miller)

MARBLING

There are many ways of marbling on fabric, and different ones suit different people. The basic principle is that thin paints are floated over the surface of water or a size to make patterns, then a piece of paper or fabric is laid gently on the surface and taken up again showing that the pattern has been transferred to it. Water can be used, but the pattern is much more controllable when it is thickened with size.

It is often just a question of getting the base medium and the thickness of the paints to suit each other and the fabric that is used.

Many patterns can be made while the paint is floating by drawing a feather, a fine pointed tool, such as a skewer or a knitting needle, or a marbling comb through the paint. Colours floating on a size do not mix with each other as they swirl and very fine flowing lines of different colours will transfer to the fabric. Apply the paints to the surface of the bath very gently indeed using a brush or dropper. If the paint is too thick, or the drops too large, the paint will sink. The colour should spread over the surface of the size as soon as it is applied, but different colours behave differently, and some spread more than others. The first colour applied will usually spread more than those added subsequently.

Clean the surface of the bath after each marbling by drawing a piece of paper across it to pick up any remaining paint.

Fabrics that are too thick will not marble successfully, nor will they if too thin, as they are impossible to handle. Colours will also appear different on different fabrics.

When you wish to marble large pieces of fabric, lay four battens on the table with a double thickness of polythene on them, dipping in the centre. Make sure that the corners are supported and that the solution will not pour out. Fill with whichever medium you are going to use. It is much easier if there are two people to handle the fabric, one at each end.

MARBLING ON WATER
The easiest method is to fill a flat tin, or plastic dish, slightly larger than your piece of fabric with water until it is about 7cm (3in) deep and spray colour on to it using metallic sprays of the type sold for use at Christmas. Swirl the

paint about and gently lay the fabric on top of it. Pick the fabric up, turn it over, and lay it on some newspaper to dry. If you find that the paint does not stick to the fabric properly, use Bondaweb instead of fabric. Leave the web on the paper and lay it over the paint with the rough side touching the paint (paper side up). When dry, lay the painted side on fabric and iron it through the paper backing. Peel the paper off. The stickiness vanishes in time.

Oil paints can be used to marble on water, if they are well diluted with white spirit or turpentine. Apply them gently to the surface of the water using a brush. Swirl or comb as before and lay the fabric (or paper) on top to lift off the print. Different colours react differently – some spread out very thinly immediately, while others stay in droplets. Lay the fabric on the paint, leave a few seconds for the fabric to pick up the paint and lift it off. Leave to dry. Wash in detergent and warm water to remove the smell of spirit. Oil paints do not need fixing.

You can try using fabric paints on water, but most of them are too thick, so thin them down, or use silk paints. It is difficult to control the patterns very well on water and you will not get much variety, but what you do get is acceptable.

MARBLING ON GELATINE
Soak one packet of gelatine in a little cold water. Dissolve it in a saucepan or in the microwave and make it up to $1^{1}/_{2}$–2 litres ($2^{1}/_{2}$ or 3 pints) by adding cold water. Cool in the fridge. Inks marble extremely well on gelatine size, but are not light fast. Use very thin fabric paints and apply them gently to the surface with a brush. Transfer the pattern to the fabric as before and lay it on newspaper to dry. When dry, fix to set the paints.

MARBLING ON WALLPAPER PASTE
Sprinkle a little cold-water paper paste on the surface of a large bowl of water. Stir well until it is mixed and leave to thicken slightly. Dilute it until it is thinner than thin cream. Pour into your dish to a depth of about 7.5cm (3in) and marble the fabric as before.

MARBLING ON CARRAGHEEN MOSS
This is the best method of all and the patterns are much more controllable. Put 28g (1oz) dried carragheen moss in

1 litre (2 pints) of cold water in an old saucepan. Boil for 5 minutes. Strain it and add another litre (2 more pints) of cold water. Allow to cool. The temperature of the size should not be less than 15°C (59°F) nor above 21°C (70°F). If it is too cold lumps will form, and it is too hot the colours will become uncontrollable. This size can be frozen if wished, or will keep for two or three days. More water should be added before it is used – between 1 and 3 litres (2 and 5 pints), depending on the result wanted. The mixture should be as thin as possible as long as the paints do not sink. However the paint might be sinking because it is too thick or you have not applied it gently enough, so you have to get all the factors right, and experience will help here.

Apply silk paint, dilute fabric paints or dilute oil paints to the surface, making patterns as before. If the paint does not spread on the surface, the size is probably too thick. Gently lay the fabric on top. Leave it for a minute and then lift it off without dragging it across the surface.

Leave to dry for at least an hour, overnight if possible. Then rinse to remove the moss solution and excess paint, and heat fix if fabric paint is used.

PATTERNS

1. Drops of colour can be applied to the surface, then more colours added to the centre of each blob, or added randomly. Allow the paints to make their own pattern.

2. Apply each colour in separate bands. Comb through these bands with a marbling comb, or an old comb from which you have removed alternate teeth leaving gaps of about 5mm ($^1/_5$in) between each pair.

3. Apply the paint with a loaded brush at intervals over the surface of the size. Draw an old knitting needle gently through the colours, meandering over the surface to make flowing patterns.

4. One colour can be applied and allowed to spread. The second colour is splattered on it by holding the brush high above the surface and beating it against a small iron bar.

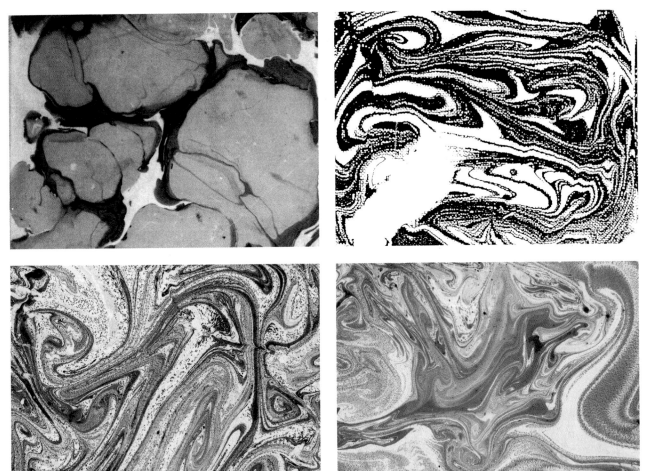

Four of the many different patterns obtainable by marbling on carragheen moss size

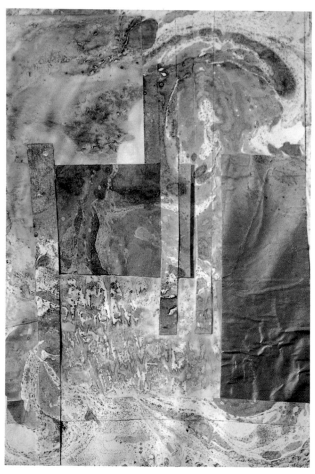

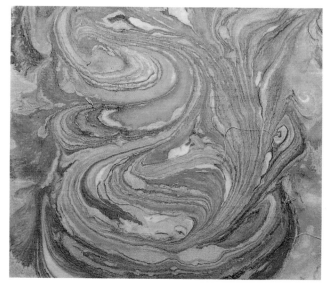

Marbling on different types of paper, to be used later for designing (Sue Luttmer)

Marbling on carragheen moss size on fine lawn

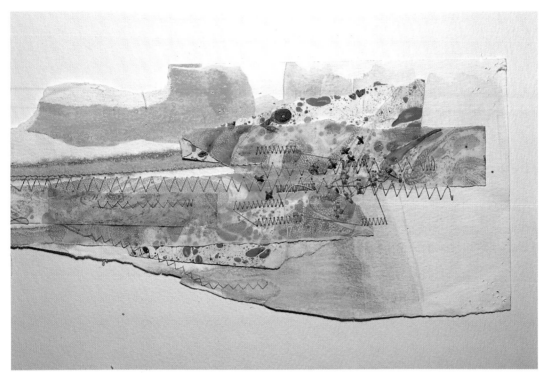

Marbled fabrics and papers bonded to a background fabric and decorated with machine zigzag and cross stitch

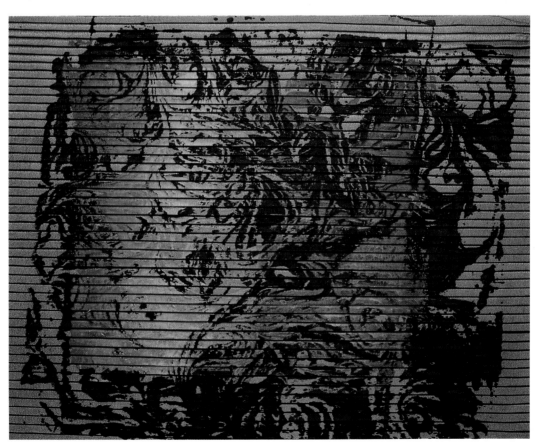

A marble design screen printed on pleated fabric (Julie Smith)

METALLIC POWDERS

Some metallic fabric paints are available, but a much richer result with more gleam can be obtained by using metallic (also called bronze) powders, which are now more common. They come in a wide range of golds, coppers and silvers, and can be mixed with coloured fabric paints to give an even greater range of colours. Because these powders are made from base metal, they will tarnish unless well mixed with a binder. PVA can be used as a binder when colouring papers, but a special bronze fabric paint medium (called bronze binder) should be used when colouring fabrics. (Ordinary fabric paint medium should not be used.) The mixture is quite fast to light but should be dry cleaned. On some fabrics it is inclined to rub off after a time, but there is a substance available which improves this.

METHOD

Mix approximately $1\frac{1}{2}$ parts metallic powder with approximately $8\frac{1}{2}$ parts bronze binder. Stir thoroughly. Some of the brightness will seem to go, but will return when the paint is dry, as the binder becomes transparent.

This paint can be applied to the fabric using a brush, roller, or sponge; it can be block printed; or it can be screen printed. It is better to mix the paint just before use, as it can become dull when kept. The paint can be diluted with water if necessary, and the brushes and equipment can be cleaned with water, but this must be done before the paint has been allowed to dry, as it is then impervious to water.

Allow the paint to dry. Fix it by baking or ironing it for 5 minutes at 140°C (275°F).

METALLIC COLOURS

This metallic mixture can also be coloured by the addition of powder or paste pigments, fabric paints, or acrylic paints. A small amount can be added just to change the colour of the metal, or a large amount so that the metal is a very subtle addition to the colour.

PEARL COLOURS

A pearl binder is also available which is coloured in the same way as the metallic paint. It is heat set in the same way.

A selection of metallic (bronze) powders

OPPOSITE *A bag made from bonded scraps of fabric decorated with gold and silver paint with applied squares of machine drawn thread work and machine stitched loops using the tailor-tacking foot*

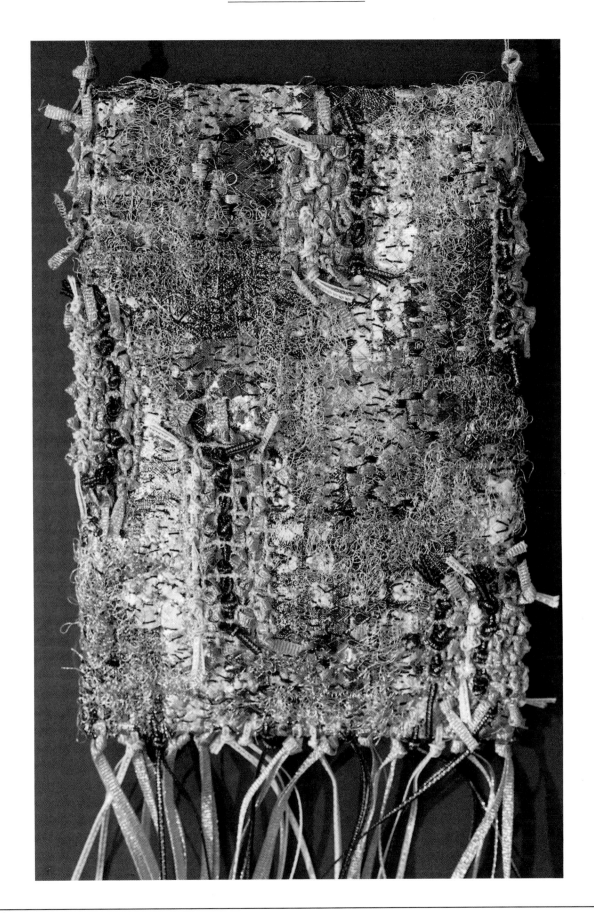

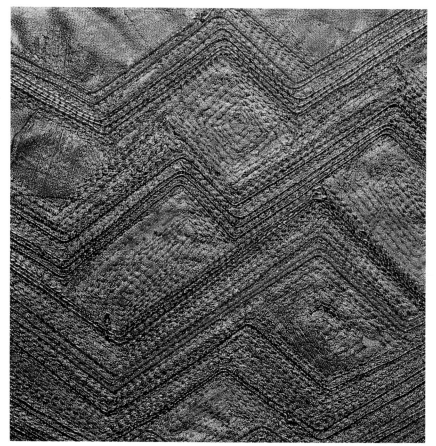

LEFT *A resurrected disaster. A layer of stitching painted over with gold paint, and more red and blue stitching on top*

BELOW *Hand-made paper and scrim, painted with black Quink ink and partially bleached. Gold and coloured paints were dabbed on. The grid pattern was made by laying paper on top of this, then making a grid of corn fibres over the top and painting it gold. The stitching was done in variegated metallic threads and the centres of the squares torn away (Corliss Miller)*

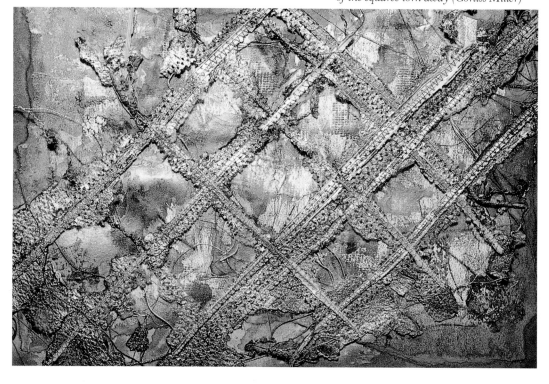

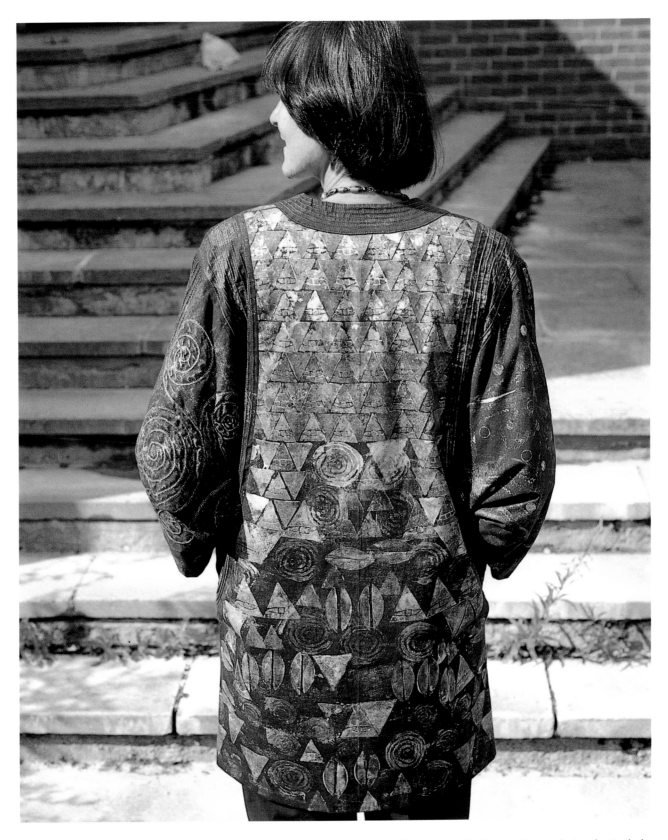

A coat made from black cotton printed using gold and silver paint made from metallic powders. Machine stitching and pintucks give body to the fabric (Thea de Kock)

FINISHED PIECES

A panel with a piece of block-printed fabric applied to gold silk. The pattern is built up with applied pieces of leather and transparent fabrics and embellished with running and herringbone stitches (Jan Hayes)

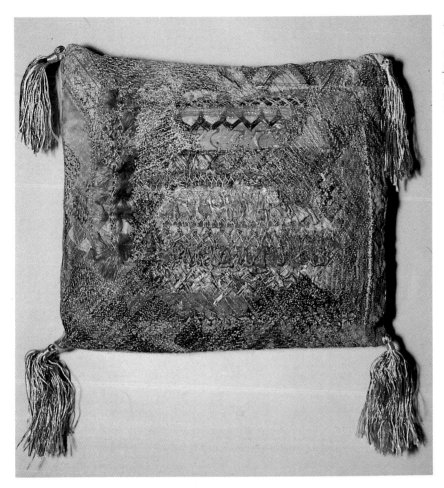

A cushion based on a design using triangles. Transfer printing, block printing using rubber stamps and a variety of sponged fabrics are applied to a backing and embellished with free running and zigzag worked by machine, and herringbone and tufting stitch worked by hand (Julie Smith)

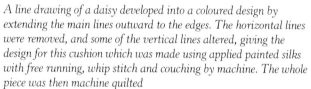

A line drawing of a daisy developed into a coloured design by extending the main lines outward to the edges. The horizontal lines were removed, and some of the vertical lines altered, giving the design for this cushion which was made using applied painted silks with free running, whip stitch and couching by machine. The whole piece was then machine quilted

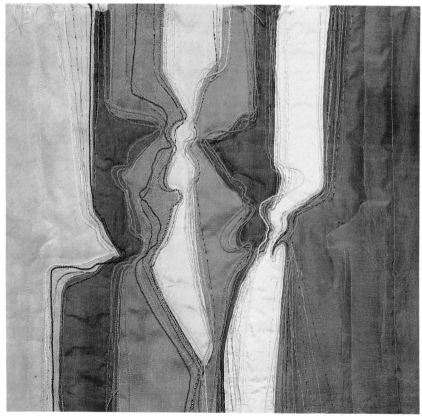

The same design was then cut into squares, which were arranged in two or three different ways. One arrangement was chosen for the second cushion. The design was drawn on squares of silk using transparent gutta and painted with silk paint. Each square was machine embroidered before being pieced and, finally, quilted (Janet Butler)

LEFT *A panel based on a drawing of daisies, drawn on fabric using a technical pen with hand and machine embroidery (Jean Mould)*
ABOVE *A detail of the daisies panel, using satin stitch and french knots (Jean Mould)*
RIGHT *A detail of a triptych based on a cornfield. Hand stitching on painted fabrics (Jean Mould)*

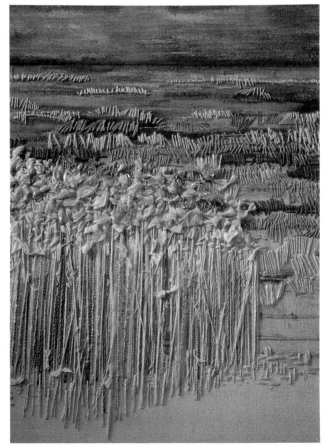

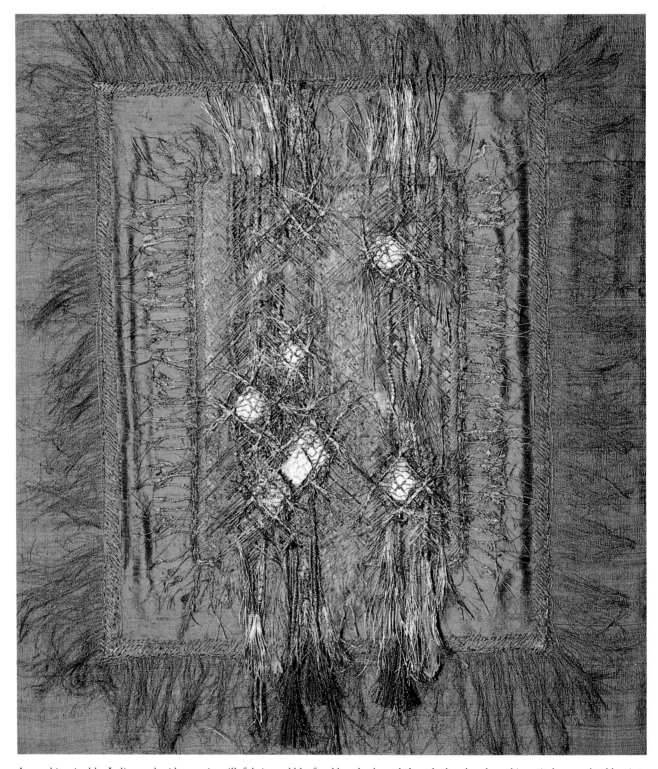

A panel inspired by Indian embroidery, using silk fabrics, gold leaf, gold and coloured threads, hand and machine stitchery and gold paint applied after the stitching (Jean Draper)

A book based on English medieval tiles. The cover was printed using fabric paints; layers of fabric were stitched through and parts cut away, then machine made lace added and finally gold paint applied on top (Sandy Chester Jones. Photographs by Sandy Chester Jones)

Details of two of the pages showing cutwork, hand and machine embroidery in an attempt to emulate the richness of medieval missals

A framed embroidery based on a project on Elizabethan costume. Silk, calico, paper and transparent fabrics were coloured with fabric paints and pearlised fabric paints and decorated with machine embroidery, couching and quilting (Corliss Miller)

Another panel, a detail, and a detail of a third panel, using the same methods but including cutwork and with added pearls (Corliss Miller)

A book based on a project investigating old books and arches. The cover, with a central hole, is of pelmet vilene, printed and painted, with applied pieces of stitchery and couching (Joan Powell)

Details of two of the pages showing couching, beads, applied pieces of machine stitchery and gold leaf

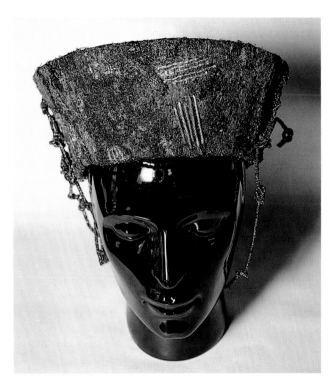

A hat for a wedding. Two semi-circular pieces of embroidery are laced together at the sides using machine-made cords (Amanda Blunden)

A detail showing applied pieces of painted fabrics covered with machine whip stitch, free running stitch and couching building up a rich surface

A mask with marbled canvas applied to felt, and machine embroidery (Julie Smith)

Design for three cushions based on a quotation of Ludvig Hevesi writing about a painting by Klimt: 'Ceaselessly coagulating into shapes and once more dissolving'. The design uses handwriting photocopied on coloured papers. The grid pattern on the first cushion dissolves into strips and re-forms into a grid of different colours on the third cushion (Linda Rakshit)

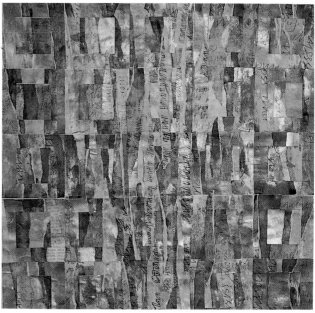

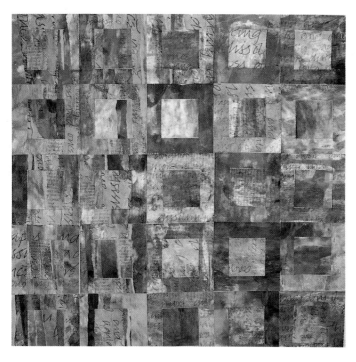

Two of the finished cushions, and details of the stitching, with screen-printed lettering, some in black some in gold with rolled fabric paints. The applied squares are quilted with gold thread, and added textures of squares of detached chain stitch (Linda Rakshit)

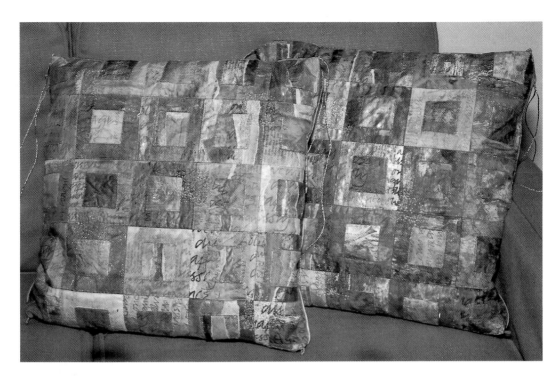

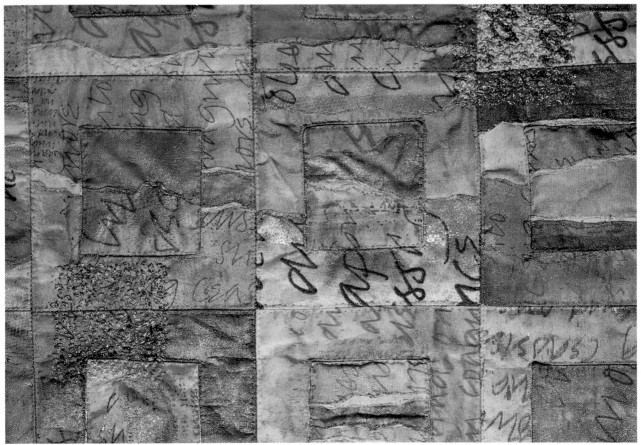

RESURRECTING DISASTERS

It is often near the end of a job that the fact that it is a failure becomes apparent. It is depressing to have spent so long on a piece of work that will not turn out right, and the inclination is to throw the whole thing away. If this temptation can be resisted, it will often be found that something can be done to turn failure into success. Sometimes, after further treatment, the failure turns out to be the greatest success of all. Courage and persistance are needed, and a willingness to keep trying something else. After all, what is there to lose? Everyone fails from time to time, especially when something new is being tried. But try not to be too critical of your work. Are you sure it is a failure? It might be that if you pin it up on a board for a few weeks, your ideas will change and it turns out not to be so bad after all. However, if you still cannot stand the piece, try some of the following measures.

FAILURES ON PAPER

The cause of failure is nearly always because the colour is too heavy looking, or the pattern too busy.

One solution is to cover most of it up with:

1. Black Quink ink, which can then be bleached back to show some of the original colour.

2. A very thin layer of white or pale coloured emulsion, and then a little more paint added in certain layers.

3. Gold paint rolled or dabbed over parts of the paper, allowing some of the colour to show through.

What all these remedies have in common is that they reduce the brightness, density or contrast of colour and even out the busy-ness, giving a calmer surface which can then be added to and built up on in some areas to give a centre of interest. Decide which area is to be the centre of interest and add more colour there, but be gentle. You can always add more, but it is difficult to take away.

FAILURES ON FABRIC

Sometimes the colour looks thin and wishy-washy, with very little pattern or design. The remedy here is just to do more – another layer of whatever was first done, or something different such as overprinting marbling using a cut potato, or rolling more colour over spattering.

Sometimes the wrong method or the wrong paint is

chosen for a particular type of fabric. To avoid this, do small samples of each method on many different fabrics. However, if it has happened, just work over it with the right method or paint, covering it either completely or in parts.

Sometimes the failure is much the same as that on paper – colours that are too strong or too heavy, or a pattern that is confused, meaning that the whole thing looks a mess. So cover it with:

1. Black or dark coloured Procion MX dye, which can be gently bleached back in parts, but leaving enough dark tones to pull all the rest of the colours together and cover up some of the confusion.

2. Deka Opaque paint, which will cover up anything, applied with a brush or roller.

3. Gold or silver paint which will also cover up anything, applied in the same way, or sprayed on.

4. Pieces of coloured silk or transparent fabrics, stitched down in a colour which blends them with the paint.

5. A complete layer of fabric, either opaque or transparent, or a mesh, which is then cut or slashed to allow some of the underneath to show.

6. Fabric cut or torn into strips or shapes, and laid over the painted fabric in some sort of pattern. Then stitch to hold the pieces in place, making the stitching blend and merge (or outline) the pieces.

Sometimes none of these methods work, and often this is because the whole piece is finally too heavy and solid with all the layers of colour, paint and fabric that have been used. This is when the whole thing can be totally covered again with a layer of gold paint, or with gold leaf glued on with a dilute solution of PVA (Marvyn Medium), making it even more solid. This is then used as a substitute for gold leather, cut up into small shapes and applied to another piece of work, highlighting parts of the design. Keep a box of these pieces to hand; they will often be just what is needed at the time and you will be pleased to have found a treasure at last.

A panel commissioned for a dining-room wall at Urchfont Manor, Wiltshire, using many different fabrics painted with emulsion, silk and fabric paints and bronze powders, with hand and machine stitching (Marian Murphy and Heather Marsh)

FURTHER READING

Some of these books are out of print, but may be obtained from your library.

African Textiles and Dyeing Techniques, Claire Polakof (Routledge & Kegan Paul)
Batik for Beginners, Norma Jameson (Studio Vista)
Dyeing and Printing, Ash & Dyson (Batsford)
Fabric Dyeing and Printing, Stuart & Patricia Robinson (Newnes)
Fabric Printing and Dyeing, David Green (MacGibbon & Kee)
Hand Block Printing and Resist Dyeing, Susan Bosence (David & Charles)
Ideas and Techniques for Fabric Design, Lynda Flower (Longman)
Monoprint Techniques, Frederick Palmer (Batsford)
The Dyer's Art, Jack Lenor Larson (Van Nostrand Reihold)
The Art of the Needle, Jan Beaney (Century Hutchinson)
The Technique of Batik, Noel Dyrenforth (Batsford)
Transfer Printing onto Man-made Fabrics, Guy Scott (Batsford)
Screen Printing, J. I. Biegeleisen (Watson Guptill)
Silk Screen Techniques, Biegeleisen & Cohn (Dover)
Screen Printing, Nicholas Bristow (Batsford)
Painting on Silk, Jill Kennedy & Jane Varrall (Dryad Press)

Suggestion for a chair using decorated fabrics

\intUPPLIERS

The following suppliers will all send a price list on request, and goods by post.

ART VAN GO, 16 Hollybush Lane, Datchworth, Knebworth, HERTS, SG3 6RE
Aquarella, bronze powders, Javana silk paints and markers

BERNINA, Bogod House, 50–52 Great Sutton Street, London EC1V 0DJ
Sewing machines

L. CORNELLISON & SON Ltd, 105 Great Russell Street, London WC1B 3RY
Art supplies, rollers, fabric paints, bronze powders, bronze fabric medium

HUSQUVARNA & PFAFF, Husquvarna Viking House, Cheddar Business Park, Wedmoor Road, Cheddar, SOMERSET, BS27 3EB
Sewing machines

FOUR SHIRE BOOKS, 17 High Street, Moreton-in-Marsh, GLOS, GL56 0AF

JANOME, Janome Centre, Southside, Bredbury, Stockport, CHESHIRE, SK6 2SP

KEMTEX CRAFT DYES, Chorley Business & Technology Centre, Euxton Lane, Chorley, Manchester, LANCS PR7 6TE
Procion fabric painting kit, fabric painting kit

KHADI PAPERS, Chilgrove, Chichester, PO18 9HU

PAPER SHED, March House, Tollerton, York, YO6 2EQ

RAINBOW SILKS, 6 Wheelers Yard, High Street, Great Missenden, BUCKS, HP16 0AL

GWEN HEDLEY, Strata, Oronsay, Misbourne Avenue, Chalfont St Peter, BUCKS, SL9 0PF

GEORGE WEIL, Old Portsmouth Road, Peasemarsh, Guildford, SURREY, GU3 1LZ
Deka and Pebeo paints, Hunt Speedball screen printing equipment, fabrics prepared for printing, sponge 'brushes', L & B diffusers, Procion Mix in small quantities, manutex, wax etc.

INDEX